THE GOLDEN FLEA

ALSO BY MICHAEL RIPS

Pasquale's Nose

The Face of a Naked Lady

THE
GOLDEN
FLEA

*A Story of Obsession
and Collecting*

MICHAEL RIPS

W. W. NORTON & COMPANY
Independent Publishers Since 1923

For information about special discounts for bulk purchases, please contact
W. W. Norton Special Sales at specialsales@wwnorton.com or 800-233-4830

Manufacturing by LSC Communications, Harrisonburg
Book design by Lovedog Studio
Production manager: Lauren Abbate

ISBN 978-1-324-00407-3

W. W. Norton & Company, Inc., 500 Fifth Avenue, New York, N.Y. 10110
www.wwnorton.com

W. W. Norton & Company Ltd., 15 Carlisle Street, London W1D 3BS
1 2 3 4 5 6 7 8 9 0

For Sheila and Nicolaïa

Contents

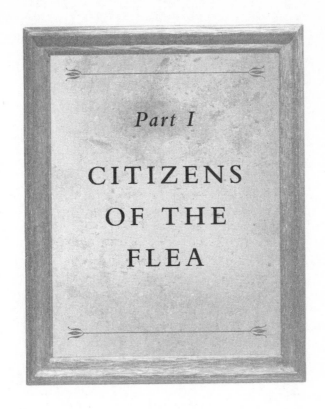

Part I

CITIZENS OF THE FLEA

1

A BLACK MAN IN A WHITE HAT STOOD SLEEPING against a brick wall. Next to him a long ramp. On the other side of the ramp, a white man in a black hat. Snow gathered at their feet.

At the bottom of the ramp was a parking garage.

There were people in that subterranean space.

They talked, smoked, and set up tables. Steam from their coffee rose into the air from the street. It was four-thirty in the morning.

The black man, now awake, pulled the brim of his hat down to cover the hole where his eye had been.

Unlocking the chain that extended across the entry to the ramp, he led me into his cave.

From there, I have yet to return.

. . . .

INSIDE THE CAVE, the man walked me to his table. Retrieving a lawn chair, he lay down and slept.

Among the objects on his table were slices of carpet, abandoned suits from the laundry down the street, appendages of

dolls from the 1950s, a pair of tan shoes with broguing, a woman's golf bag, a stack of drawings from a high school art class.

None of these had prices, and all were assembled into a single mound.

When the man awoke, I asked whether he would retrieve an item—the shoes.

"What will happen if I do that?" he asked.

"Everything collapses?"

"Would you like that?"

"I suppose not."

"Then why trouble me?"

The man had crooked teeth but plush, purple gums that sparkled when he spoke.

At the next booth sat a small man with sentimental eyes. Against his table were a pair of metal crutches. Five empty frames hung behind him on the wall of the garage.

"This," I said, pointing to one of the frames. "Do you know where it is from?"

It was hand-carved and leafed in silver.

"No."

"Or this one?" I pointed to another.

"No."

Any of them?

"No."

I took down a frame.

"Do you like it?" he asked.

I paused.

He smiled.

A frame or painting or antique table encountered anywhere else, a gallery, museum, or home, comes with an explanatory context: it may be near similar frames, paintings, and furniture with which it shares a style or provenance; it may be accompanied by a text; the owner may have a reputation for collecting things that are important or interesting or, at any rate, are not forgeries.

But here the objects were naked, and effulgently so.

• • • •

THE GARAGE HAD two floors. On each, twenty-five to thirty booths ran along the brick walls, and twenty booths were set up in the center. In all, there were one hundred vendors, offering paintings, lithographs and photographs, ceramic vases, silver trays, models of ancient ships from museum gift shops, boxes of cuff links, kimonos, used napkins and tablecloths, dinnerware, picture frames, pliers, gold and silver brooches and necklaces, antique rugs, lamps, chandeliers, and furniture from all periods, mug shots, canes, vintage clothes, costume jewelry, Asian scrolls, screens, and jade, sports memorabilia, and African art. And throughout there were stacks of crumbling newspapers and magazines.

On top of one of the stacks, on my first day there, was a newspaper from the 1950s, announcing that outside a small town in Iowa, not far from where I had grown up, a child had been devoured by a combine. There was a picture of the combine, the driver of the combine, slumped to the ground, and an ambulance. A man from the ambulance had his head

turned, looking for the child. But, as the driver knew, no child remained.

Oil and gasoline pooled on the floors from the cars parked and serviced in the parking garage during the week. When it rained greatly, shards of paint and filth fell onto the booths and sewage backed up through the drains. Fluorescent lights and asbestos hung loosely from the ceiling, and nails protruded from the walls, hammered there by vendors to display their paintings. With no heat, vendors warmed themselves with coffee and layers of coats. Nonetheless, the concrete walls seemed capable of withstanding any assault, and the pipes that lined the walls did well as supports for vintage clothes, tablecloths, stall signs, and anything else that couldn't fit on the crowded floors.

Beyond the garage was a constellation of open-air parking lots, which were also rented out to vendors on the weekends. There were three large lots on Sixth Avenue between Twenty-Third and Twenty-Seventh Streets. Down Sixth Avenue, between Sixteenth and Seventeenth Streets, was another lot; this was the smallest of the lots and was, typically, the last that a buyer would visit. On Twenty-Fifth Street between Sixth and Broadway, next to a large church (once Episcopalian, now Serbian), was another parking lot used as a flea market on the weekends. Edith Wharton (then Edith Jones) was married in the church.

Visitors to certain lots on Sixth Avenue were required to pay a fee to get in, usually a dollar. The lot next to the church required the same. If, however, you wanted to get in before nine o'clock, the fee was $5. Early access meant

that the buyer would get a first look at what was being sold by the vendors. Some of the lots opened as early as five or six in the morning. Vendors who arrived at that time traded goods with each other.

Across the street from the parking lot on Twenty-Fifth Street was a building that housed dozens of antiques dealers, each with their separate stalls and metal security grates. Some were open during the week, others were not. Those vendors who were not open would leave a note with their phone number on the outside of the stall. All vendors, though, were open on the weekends, owing to the crowds drawn to the neighborhood by the flea market. A similar building was just east of the garage on Twenty-Fifth Street.

Both buildings, along with those that surrounded them, had once housed businesses connected to the Garment District, which ran from the mid-Twenties up to Forty-Second Street and from Fifth to Ninth Avenues. At one time, over 90 percent of the clothing sold in America was manufactured in the Garment District. That had dropped to 3 percent.

In the 1970s and '80s, as the garment industry evaporated, a cataract of underground clubs, prostitutes, artists, transvestites, writers, and junkies flowed into the neighborhood. At the same time, with the price of real estate rising in the West Village, gays and lesbians moved into Chelsea, which was nearby and more affordable. Gay bars and sex shops filled Seventh and Eighth Avenues. Robert Mapplethorpe and Patti Smith took up residence in the Chelsea Hotel in 1969, and Sid Vicious of the Sex Pistols killed his girlfriend there in 1978. The flea was a meeting place for the various

groups filling Chelsea: rare yet inexpensive items could be found to fill their apartments, artists took inspiration from the accidental combinations of objects, and those who were leaving the clubs and bars in the early morning had a place to go before returning home. People dressed in outlandish costume just to attend the flea market. It was a place to display and create oneself, a diorama of drag and exoticism.

During this period, a man purchased long-term leases on the garage and surrounding parking lots in Chelsea, and on the weekends he rented those out to flea market vendors. From the beginning, when vendors would fall behind on their rents, he would come down to the flea with his brother and announce the amounts that the vendors owed. If the vendors objected to this behavior, they were thrown out. The brother carried a baseball bat.

Vendors, whether in the garage, open lots, or converted buildings of Chelsea, paid a fee to sell their goods. For those who did not wish to pay a fee, they could set up on the sidewalk on Sixth Avenue between Twenty-Third and Twenty-Fifth Streets.

This constellation of secondhand markets was known by New Yorkers, and to a host of others who came from beyond the city, as "the flea." Many of those who came to the flea were familiar with similar markets in Paris and London, and many were themselves dealers. Together it may have been one of the largest flea markets in America. It was certainly among the best known, and widely regarded for the treasures to be found there.

· · · ·

Born in Nebraska, I viewed most objects as contaminated.

My father and mother, who had grown up with antiques and had inherited antiques from their families, wanted little to do with them. Those objects, their histories, were linked in my parents' minds to the events that had carried their brothers to war in Europe, where they were killed, or injured for life. The antique was a cesspool, and flea markets its tributary. In New York, I lived with little but my books and journals. They were piled in a corner near a single chair and desk. Nothing hung on the walls, no rugs covered the floors.

My wife, Sheila Berger, grew up in St. Louis. Her family enjoyed spending their weekends at estate and garage sales. On occasional trips to visit them, I would accompany her family to the sales but would remain in the car. One July day in St. Louis, the heat was such that I was forced to leave the car and join the others. I sat down next to the woman who had been collecting money from the sale. She told me that the couple who owned the home was elderly and moving to a nursing home in Florida. She had been hired to sit in the house that day and sell off what she could.

Between the woman and me was a stack of rolled posters from auto shows and movies. One, however, was different: a geometric assemblage of blue lines, which, upon closer look, revealed themselves to be the outlines of long neon bulbs. Decades before, the couple had attended the exhibition of an artist at a local museum, purchased the poster, and asked the artist to sign it. My guess is that the couple—Brilliant was their name—had put the poster in a tube that afternoon and there it stayed until, forty years later, I unrolled it.

The artist who signed the poster devoted the rest of his life to constructing sculptures from neon lights and for that reason may well have been amused when he inscribed in large letters across the top of the poster: TO MR. AND MRS. BRILLIANT, DAN FLAVIN. I bought the poster, brought it back to New York, and hung it on the wall of my office, where I worked as a young attorney. A day or two later, I received a call. It was from the director of a museum in New York. An artist whom the museum represented had passed away, and the director was looking for an attorney to handle the estate. The director was concerned that the lawyer be familiar with the artist—Dan Flavin.

After serving in the Air Force, Flavin had returned to New York in the 1950s, where he began his career. In 1961, while a guard at the American Museum of Natural History, Flavin designed works of art that incorporated electric lights. By the mid-1960s, his work contained no elements other than electric tubes. Over the next two decades, the complexity and size of his sculptures grew. In 1992, the light from his work filled the rotunda of the Guggenheim Museum. He is now widely regarded as one of the most important artists of the twentieth century.

Explaining that a signed poster of one of his earliest exhibitions was on my office wall, I was hired. My next years were spent working with the artist's estate and on arranging the funding for a museum that would honor him and other minimalists. With the museum completed, I left the law and moved to Italy, where I lived with my wife and newborn daughter. My wife painted and I wrote.

A year or two later, we returned to New York and moved back into the Chelsea Hotel. The hotel, which opened in 1884, originally housed cooperative apartments but was converted to a hotel in 1904. It became a home for writers (Dylan Thomas, Tennessee Williams, Jack Kerouac, William Burroughs), directors and actors (Milos Forman, Stanley Kubrick, Sarah Bernhardt, Dennis Hopper), and musicians (Janis Joplin, Leonard Cohen, Jimi Hendrix).

Stanley Bard, one of the owners of the hotel, was especially interested in artists, and many of the most famous stayed there. Their paintings hung on the walls of the hotel. Because my wife was a painter and sculptor who had shown at a number of important galleries, she and Stanley Bard got along, so we were admitted. When we first arrived, Herbert Huncke, the Beat poet, was still living in the hotel, and Arthur Miller, who had lived in the hotel, was often in the lobby. Ethan Hawke was our neighbor. Eventually we moved into the former apartment and workshop of Charles James, the fashion designer.

At the time that my wife and I moved in, I'd become interested in the writings of Emmanuel Levinas, a Lithuanian who studied in Germany under Edmund Husserl and Martin Heidegger. When the Nazis came to power, Levinas was placed in a labor camp. When released at the end of the war, he learned that most of his family had been executed. The rest of Levinas's life was spent writing about the universal mystery that surrounds us and is most succinctly found in those with whom we are most intimate—parents and lovers—as "the face of the Other." Neither our engagement

nor our comprehension of the Other is ever complete—and this struggle, this unsatisfiable preoccupation, leads us to awe and piety. It also shaves away our narcissism as we are confronted by something that is prominently and immutably not us. We begin to see our victims, as if through a clearing mist, whether next to us in bed or on the other side of the world. For this we owe a debt to the unknown, and our new sight gives rise to a sense of reciprocal obligations, hence ethics.

Using my savings to support myself, I intended to study Levinas and his influence on other philosophers. There was also a plan to write a play about the poet Paul Celan. Born in 1920, in what is now the Ukraine, Celan lost both of his parents in the Holocaust and was himself imprisoned in a forced labor camp. After the war, Celan moved to Paris, supporting himself as a translator as he worked on his poems. Those poems, dense, enigmatic, and written in German, are some of the most important works of the postwar period. Celan killed himself in 1970. To write about Celan, I would have to learn German, which left me sitting in coffee shops and cafés in and around the garage on Twenty-Fourth Street, where in turn I discovered the flea.

. . . .

STARING INTO THE GARAGE that first morning, I recalled my good fortune in that garage in St. Louis, which was why, when the man unlocked the chain to the garage, I entered. In the months that followed, I devoted myself to explor-

ing the breadth of the flea, its open lots, warehouses, and sidewalk vendors. Their offerings appeared limitless. And the more time I spent in the flea, as sellers educated me on the nature of their merchandise and their intimate relationships to those objects, the more those offerings seemed to expand.

My wife and I were once in Damascus and asked an antiques dealer where he found the best rugs. His response: "The Chelsea flea market." He explained that affluent Americans of the late nineteenth and early twentieth centuries would tour the Middle and Far East, bringing back rugs, lamps, doors, textiles, pages from illuminated manuscripts, and hand-painted miniatures as souvenirs. The children and grandchildren of these people had neither the taste for nor the understanding of these objects to retain them, so the objects ended up in the flea. The Syrian came to America four or five times a year just to buy at the flea.

The flea was an ideal place of business for vendors as well as buyers: Vendors could set up at the last minute, could stay for a weekend or a year of weekends, and no background checks or credit references were required; no taxes were paid, barter was accepted, and vendors could be as irrational in pricing as they liked. Vendors also had license to be as ingratiating or as insulting to customers as they wished, and many of those customers were capable of spending a great deal on what the vendors were selling.

For most, whether vendor, buyer, visitor, or picker, the flea was a weekend activity. These individuals had their

attachments elsewhere, and it was to those that they returned on Monday. The flea was that for me when I first came to the frigid cave and for months thereafter. But over time it became something else—a consumptive engagement with the unknown.

2

MONTHS AFTER MY FIRST ENCOUNTER WITH THE man at the entrance to the garage, I was back at his table in the lower level. He was at the same table at the bottom of the ramp. Well over six feet tall, he stood mute and motionless, staring not at the goods on his table nor the interior of the garage but at the entrance to the garage at the top of the ramp. The light from the street, digested by the gold jewelry around his mammoth chest and his large metal sunglasses, vibrated back from his head and torso in long spears of light.

He was Jokkho, the warrior deity of Hindu legend. Jokkho, who guarded the hidden and sacred treasures of the earth. He was capricious and, at times, malevolent. His size, glowing torso, missing eye, dark glasses, and beard of a different color every weekend led people to avoid him. Even those vendors who had been with him in the flea for decades kept a distance.

"Do you happen to know anything about this?"

I was holding a sandstone sculpture. Six inches tall, it featured a naked woman wearing a hat.

"No," said Jokkho. At no point did his gaze turn from the entrance to the ramp.

"Do you think it's Mayan?"

"Do I look to you like an expert in Mayan sculpture?"

"Do you remember where you got it?" I tried again.

"No."

"When you got it?"

"No."

"Anything about it?"

He was silent.

After time had passed:

"There's one thing I can tell you," he said.

"What's that?"

"You're annoying me."

Since the owner of the flea took no money from vendors other than a set rental fee, he was indifferent to how much the vendors sold at their booths. This meant that Jokkho, who appeared to sell little and seemed to have the unlimited wealth of a deity who protected treasures, was welcome to accumulate as many booths as he wished—so long as he paid for them, which he did.

Of the hundred or so booths on any weekend afternoon in the garage, Jokkho controlled a good fraction, and all of them were set up in the same way: in the center of each booth was a small devil of shredded and damaged items so tightly packed as to be inaccessible. Jokkho also felt the need to rotate these structures between his booths, which he did through the efforts of a crew, which over the years had become expert in the transportation of Jokkho's goods from one end of the garage to the other. Despite their expertise and hard work, Jokkho felt it necessary to berate them in

front of everyone in the flea for the slightest diversion from the instructions that Jokkho had given to them. The men themselves received this in silence, but the other vendors did not think it appropriate. What they also thought unfair was that Jokkho was taking up spaces in the garage that could have been used by older vendors, who would have been better off inside the garage instead of in the heat, rain, and snow of the open lots.

In the years that I knew him, I would learn little of Jokkho other than that he was born in New England and that he owned there an antiques shop. Jokkho would spend his days traveling to small towns in New England, where he would purchase furniture, paintings, and oriental carpets.

When he discovered that his wife was sleeping with a neighbor, Jokkho moved to another town. Again, he set up an antiques shop. Someone in the flea told me that a man came into Jokkho's shop one morning, pushed a knife through Jokkho's eye, and left with whatever money was in Jokkho's pants. When Jokkho recovered, he closed his shop, moved to New York, and only sold in flea markets. He felt safer there.

· · · ·

THOUGH JOKKHO CLAIMED to dislike everyone, he had an affection for my young daughter. I used to bring her to the flea, and our trips became a weekend ritual that lasted for years: the two of us would leave the hotel between five and six in the morning, pass the garbage bags lining Twenty-Third Street, exchange glances with those heading home

from the clubs, admire the unclothed female forms displayed in the windows of the mannequin shops on Twenty-Fourth, and then, just before Sixth Avenue, climb into the concrete hole that was the back entrance to the cave.

By the time my daughter was five, she was tall enough to see what was on top of Jokkho's tables. She delighted in struggling to dig through what was there to find costume jewelry or an old doll. My daughter would run to Jokkho, who would hug her and say, "Does the old broad want candy?" If she said yes, which she always did, the two of them would go off hand in hand to find it. It might take Jokkho an hour or more to locate what he considered the right candy for her. This caused me no concern; I saw in Jokkho an unblemished sympathy for a little girl who had her own trouble fitting in. They always returned, and she was always delighted by their adventure.

When Jokkho and my daughter were done with their stroll, the three of us would meet in a store on the corner of Sixth Avenue and Twenty-Fourth Street. At the time, New York was attempting to rid itself of strip clubs, pornographic bookstores, and video shops. Unless the bookstore or video shop maintained a certain percentage of material that was not obscene, it would be closed by the police. In order to make certain it met that requirement, the owner of the store on the corner filled over half of his store with an inventory of used children's books and movies.

As much time as I spent with Jokkho, he was never knowable. It was impossible to tell whether he was gay or straight; rich or poor; educated or uneducated; whether he was fifty or eighty. Nor was one able to discern how he knew more

about antiques than anyone else in the flea; where he lived; or whether he disliked people as much as he claimed.

It was possible that on Mondays, Jokkho became something else. That he worked in an office, wore a tie, had lunch with others. That he smiled every afternoon at the woman in the subway booth and that he phoned his relatives and expressed his sympathy for those friends who were sick. It was that way with everyone at the flea. Whatever they were during the week, there was a transfiguration when they entered the flea. They became, knowingly, willingly, devoutly, the people of the flea.

As soon as my daughter, Jokkho, and I returned to the garage, she would rush down one of the two aisles toward the north end of the flea. I stayed behind chatting with Jokkho. At no point did I worry that she would leave the garage for the street or encounter someone who was dangerous to her. The vendors all knew her and watched after her.

Most of the time she would hide in one of their booths, usually under a table. There she would wait for me or my wife to find her. Once we did, she would repeat the game. In the flea, she was at her happiest.

· · · ·

ONE MORNING, WHEN my daughter was not at Jokkho's nor in any of the booths where she usually hid, I started searching the garage. A man in his fifties, athletic, with shoulder-length silver-blond hair and a long, faceted face, approached me.

"Are you looking for a young lady? If you are, you shall find

her in the Lillys. Not the new Lillys. The old Lillys, which says something about your daughter. Old Lillys are what you want. She knows that. Come next Saturday and I'll have some in her size."

He advanced ahead of me. Arriving at two small racks of used clothing, he stopped. On a table next to the racks were belts, triangular flags used in boat races, books, women's sweaters, bags of crested buttons, and a copy of *Story*, a literary journal from the 1930s.

Approaching one of the two racks, the man separated the dresses and coats. Out popped my daughter.

"Lilly Pulitzer," the man began, addressing neither me nor my daughter but the clothes on the rack where my daughter had been hiding, "got the name Lilly from her mother, who, as you may know, was an heiress to the Standard Oil fortune. She was at Chapin with Jackie, and it was Jackie who, when Lilly started making clothes, wore one of these . . ."

The man inserted his hand into the racks and extracted a dress.

"The classic shift, which, when Jackie was photographed for *Life* wearing it, put Lilly on the map. I knew the Pulitzers from St. Louis, which is where my mother's family lived, and some of the Pulitzers, I suppose, are worth knowing. That's only my opinion, you understand."

I interrupted to point out that my wife was from St. Louis.

"She will definitely know the Pulitzers," the man continued, "and, no doubt, my family. We should get your wife and my mother together. We'll do it at the Greenwich Country Club. Mother's the grande dame there."

He pulled a bacon-and-cheese sandwich from a Bottega Veneta shopping bag.

"Johny's," he said, indicating the source of the sandwich.

Johny's, a diner popular with the vendors, was next to the garage. The diner was not more than ten feet wide and had only fifteen seats, nine of which were at the counter. It was the sort of place people went to before showering in the morning. Consequently, the customers offered an assortment of aromas, including cigarettes and marijuana, gin and beer, and unwashed hair, which mixed with frying bacon, onions, and garlic. Its limited seating, reputation for better-than-average pancakes, and low prices meant that Johny's was always filled. Johny's was so close to the flea, vendors didn't need to leave their booths for long in order to get a coffee to go.

The man with the silver-blond hair withdrew a flask from his coat and took a drink.

"English," he said, referring to the flask. "Crystal, with a hammered silver bottom. The hallmark . . ."

He flipped the flask over.

"James Dixon. You like that French pastry shop on Twenty-Third."

It was true, but how would he know that? And I wondered what the connection was between the flask and the pastry shop.

"The madeleines at Sprüngli are better, but, to be honest with you, I haven't been there in years."

As he headed into a description of the menu at Sprüngli, which, I learned later, was in Zurich, I sorted through his

face. Gray eyes, a long nose, skin tightened by the sun and agitated by sources unknown to me and possibly him. From none of these, either on their own or together, would one imagine that he was handsome. But he was.

He removed the rubber band from his ponytail, causing his glowing hair to dash to his shoulders.

"I need a smoke. Take over my booth," he said, exiting the booth and garage, pulling a cigarette from his shirt pocket.

Take over his booth? I had no experience selling clothes or books, and none of what he sold had prices.

But I was not entirely unprepared for my new assignment. Reverting to what I had been trained by generations of family to do, I removed a book from the table of books, unfolded a chair at the back of the booth, and then, sitting in the chair, the book on my lap, assumed the air of a man who was in the middle of his lunch break and should not be disturbed.

A black man entered the booth. He was exceptionally well dressed.

"Where's Paul?"

I assumed he was asking after the man with whom I was just speaking. I informed him that Paul had left for a cigarette.

"He's got a tweed for me and an umbrella, hand-carved and assembled in Milan," the man said. "I've been waiting for weeks."

I asked if he regularly shopped at Paul's.

"People 'shop' at the sort of places which I do not care for.

Paul is my consultant, my guide. Before Paul, I looked like every other poseur. When I wear Paul's clothes, I look like a gentleman."

He glanced at my clothes disapprovingly, and then at one of the two racks.

"You see this," he said, pointing to the center of the rack and then pulling out a green leather jacket.

"Arandú. The best shop in Buenos Aires. Near the Alvear Hotel. I assume you know the Alvear."

He returned the jacket to its hanger.

"Or this."

He turned a tie over and displayed the label. Charvet.

"Do you appreciate any of this?" he asked. "Or am I wasting my time? You give the appearance of someone who is witless. Not the right impression for someone selling sophisticated merchandise. Tell Paul to call me when he gets back."

As the man left, he was replaced by a stout man wearing cologne, who went straight to the women's clothes. To discourage any questions from this new customer, I leaned back and pulled the book over my face. It was Robert Lowell's *Life Studies*.

From the other side of the book, I heard footsteps. I needed something to drive back this intruder and his questions. Nothing was on Paul's tables, nor in the nearby booths.

And then I saw it. Right in front of me. A weapon that had, since antiquity, driven off the strongest and most determined. Poetry. I began to read out loud.

Just then the footsteps stopped.

"Your cadence stinks." It was Paul. He was wet. But he was a chain smoker and that forced him to stand outside despite the rain.

"You need to learn how to read Lowell, and once you do, don't bother with anything after that. And I don't just mean anything of Lowell's. I mean anything of anybody."

The stout man, patiently holding a woman's shirt that he had removed from a box, interrupted.

"Excuse me," he said politely, addressing Paul.

"Yes," responded Paul, with equal civility.

"Do you know what this is made of?"

"It's made of get-the-fuck-out-of-here."

The man returned the shirt to the box and left the booth.

"It's Hermès," Paul said to me once the man had gone. "Vintage. Never been touched. I have not decided whether to sell it."

Another man approached the booth. Paul gestured him away.

"I can't believe these fucking pickers," Paul said. "They see I'm having a conversation with you, and they interrupt without ever considering what they're interrupting or whether their questions are significant. They pretend they don't know what anything is worth, hoping that you'll screw up and they'll get it for nothing. They go into my boxes and touch my clothes without ever considering whether it is appropriate to handle such a shirt or scarf, whether the shirt or scarf wants to be touched. That's incredible."

The "pickers" to whom Paul referred were those who supported themselves by purchasing objects at the flea and

reselling them to antiques dealers outside the flea. Their expertise allowed them to recognize that, say, a single and not particularly attractive vase with an oriental scene and an "AR" on the bottom was, in fact, ordered by Augustus the Strong, king of Poland, for his Japanese Palace at Dresden, with the "AR" standing for Augustus Rex (such vases, priced at $300 at the flea, could be auctioned at Sotheby's for tens of thousands) or that the abstract purple forms on the sides of a small bowl suggested that it might be thirteenth century Jun ware from China (prices for some of these were in the millions). One picker specialized in "trench art," which is art made by those, such as soldiers, medics, prisoners, and civilians, who were directly influenced by war and construct their art from the materials and debris of war. Incised shell cases and jewelry made by convalescing soldiers, for example.

Pickers also had a reputation in the flea for being aggressive negotiators. So their presence in a vendor's booth suggested that the vendor had something the vendor had mispriced and that the negotiations on that item would be difficult. For this reason, they were, as a class, unpopular among the vendors.

My wife arrived.

"Your daughter looks like you," Paul said to her. "And from what I know of your daughter, you're a good mother—not like Lowell's. Lowell's mother lorded over him. God knows, I have experience with that. One day you'll meet my daughter. Her mother and I met one night at college, snuck into a chapel, and a few months later, out of nowhere, I get a call

from her that she's having my child. We never married, never lived together. So it's been difficult."

"Paul's family was from St. Louis," I pointed out to my wife, hoping to turn the conversation.

But it was too late.

"My mother's family was from St. Louis, not my father's. Neither were the types to understand what was happening with me. Very proper, with good values, and their friends were the same. My father was an executive. I did that too. For a long time I was the vice president of a big company. When my mother invited me for lunch at the club, I knew the people there."

Stains of sweat showed where hands had knotted the ties that were on the tables, the stitching on the handle of a Goyard bag had unraveled, silks and nylons were indistinguishable. Sadness had entered the booth, and Paul, who could size up and clothe any customer, make them feel rare, did not know what to do with this customer.

. . . .

OF THE TWENTY ARTICLES of clothing that Paul displayed on Saturdays, all were otherwise hard to find or had an exceptional story attached to them. A double-breasted topcoat worn by Jamsetjee Jejeebhoy, the Bombay businessman who made his fortune in the early nineteenth century. A scarf with a pattern of turtles was owned by a woman who wore clothing only decorated with turtles, had jewelry with turtles, and had turtles on her stationery. "I knew the woman from Sand Isle," Paul explained, referring to the sun-and-white-sand summer

retreat on the coast of Florida. "We summered there. Very old families summer there." An unopened box of French-cut men's underwear from a long-closed store in Chicago.

Paul continued to mine for me the details of his summers on Sand Isle, but he would later confess that his current fantasies had nothing to do with returning there or restoring his privileged life or even leaving the flea. What he wished for was to bring together, if only for an afternoon, all the men he had clothed, and together he and they would sit, share stories, and read poetry. It would be an "Assembly of Elegant Men," he said.

A woman who had been examining two sweaters, one blue, the other peach, interrupted to ask Paul the price of the peach sweater.

"They are both cashmere," Paul responded, "but take the blue one. It's better cashmere—grade A. The peach is C and will start to get pilling and you'll come back crying to me. And peach isn't you. It may not be anyone's, but it certainly isn't you. If you want something special, look at the vicuña on the other rack. There's no cashmere that soft. I have a vicuña topcoat—made in the forties, before they banned it. In the winter, I never take it off."

The woman walked the blue sweater over to Paul. When she handed it to him, he gave her the price:

"Thirty dollars."

"Could you give me a better price?"

"Sure. Fifty."

"That's a better price?"

"For me."

"I meant a lower price."

Paul reflected.

"How about this," he began. She waited. "Get the fuck out of here."

· · · ·

IT WAS LIKE THAT every week with Paul. Never the same clothes, always a story about his family, a poem from Lowell, society names not dropped but hurled, and from anyone who bought a hunt coat with "OC" buttons Paul extracted a promise that they would never wear the coat in Middleburg, Virginia, so as to avoid the appearance that they are members of the Orange County Hunt. If members of the Orange County Hunt knew he was selling riding coats with the "OC" buttons, Paul would have to hunt elsewhere, and there was nowhere else that one would want to hunt.

I did not know whether Paul's family truly summered in Sand Isle or on Jones Beach, whether his grandmother really was a grande dame at the Greenwich Country Club or at a donut shop on Northern Boulevard. Or whether he had in fact grown up with the Kennedys, which he claimed the day it was reported that one of them was arrested for murder. Were these inventions and inflations or honest descriptions of Paul's past? I did not know.

One of the things said by visitors to the flea market was that the vendors made up stories about themselves because they were poor and uneducated, because they were the sort of people who were born ashamed, and because they sat in a garage for sixteen hours a day every weekend—a garage filthy with splintered paint and the oil and litter

from the cars that were there during the week. So the vendors were said to make up stories to feel better about themselves and engender respect from the people who came to their booths.

A vendor once told me the story of a long knit scarf that had been worn decades before in a movie by a famous actress. The vendor was an articulate woman who specialized in vintage clothing. She explained that the scarf, in no other way distinguished, was likely purchased at a thrift store by the costume designer for the movie. There were several people at the flea interested in the scarf, and the vendor sold it to a man who collected movie memorabilia. The buyer was thinking of creating a small museum for his collection. The vendor liked the idea of the scarf having a final, safe home.

People in the flea were thrilled to hear vendors tell stories of the migration of objects, like the scarf, through a succession of narratives—the original purpose of the scarf; its symbolic reuse in a movie; and its ultimate home in a collection of cultural artifacts from a particular historic period—and yet, should the vendor of the scarf attempt to suggest different narratives of her own identity, with no intention other than to find for it a final and safe place, she would be denounced as deceitful.

Paul, given his stories and his manner, was considered by some to be the most deceitful of all the vendors. But the day I met him, with my daughter in the Lillys and the sun sprinting through the flea to ignite the silver in Paul's hair, joined by the amber light from the reflections of the belt buckles hanging from a rack of clothing, none of what was said about

Paul mattered. Paul, saturated in colored light, was the central and numinous figure in a Byzantine mosaic.

My first purchase in the flea was that day at Paul's.

I had found nothing like the Dan Flavin poster and still detested the idea of bringing objects into my apartment. But I harbored a weakness when it came to clothing. My father, grandfather, and great-uncles were dedicated to their wardrobes, traveling as far as Paris to purchase the right suits and shirts. If the term "dandy" ever applied to someone from the Midwest, it applied to them. To this day, my closets are full of their suits.

Knowing this history, Paul had selected for me a silk dressing gown from the 1930s. The fabric was a heavy silk with an elaborate, vaguely Asian design. Scarred, faded throughout, and green, it recalled my relatives. Owing to its general exhaustion, the garment was in no condition to be worn, only admired. I purchased it to join the other unwearable garments in my closet.

My daughter was now on her way to another booth. Seeing that I needed to leave, Paul tenderly wrapped the dressing gown. He sought to shield it from the rain and other forces. But the gown would never be worn or even seen, and it was forever silvered in the slew of our encounter: entering his booth to find my daughter, I'd become his student, shop attendant, analyst, and, shortly, his mother's companion.

Stopping me as I left the booth, Paul held out a small plastic bag. It was taped closed. "It's for your daughter," he said. "Not for her now, but in a couple years. If she asks you about it, tell her it's from an old friend of hers, and that his name was Paul. And that he worked in a garage."

3

WITHIN MONTHS I WAS A REGULAR AT THE FLEA.
I was more than that; I was a die-hard citizen of the flea, a
regular so regular I might have worked there. The garage
was open every weekend of the year, from Saturday morning
at seven o'clock through Sunday afternoon at five o'clock.
I was there every weekend, all weekend. If I needed to be
somewhere else, I would go and then return to the flea.

Though the flea only opened early Saturday morning,
many of the vendors set up the night before. I would go
at three or four in the morning, and while they set up we
would discuss what they had found that week, and they
would educate me in etchings, ceramics, guns, oriental rugs,
portraits, animal trophies, fountain pens, corkscrews, hall-
marks, costume jewelry, Buddhas, maps, canes. They taught
me how to distinguish oriental rugs based on the manner
in which the carpets were knotted, the importance of using
black light to identify paintings that had been painted over
or repaired, how to distinguish gold leaf and artificial gold
in frames, whom to trust and not to trust.

During the day, my pattern was always the same: a silent

homage to Jokkho and his inscrutable piles of treasure and junk; a visit with Paul the haberdasher; and then into the rest of the market, where I met other vendors in an order and length of time that rarely varied. Along the way, I would encounter pickers, collectors, and the people who moved goods in and out of the flea for the vendors, pickers, and collectors. If I ran into a friend, we would leave for a café and then return to the flea. If a picker wanted to discuss something that they had for sale, we would go to the street or a café and then back to the flea.

Often I was with my wife and daughter. My daughter grew up there and developed her own relationships. Instead of on Paul, she relied for clothes and friendship on Eve, a vendor who claimed she was a descendant of a plantation owner and one of the slaves on his Jamaican plantation. She came to the United States to study psychology at Rutgers. She married a German man and loved him. He died young, and she was left with little money. The flea offered immediate support: with a refined eye for clothes and a honed understanding of what women in the flea were looking for, she bought designer dresses, scarves, and shoes from thrift stores in New Jersey and resold them in the market. Like Paul, she lectured her customers, including my daughter and her friends, on stitching, the hand of a fabric, and the history of design.

Once a professional tennis player, Eve had grown large. This affected her health. When she was unable to walk, owing to swelling in her legs that often lasted months, she could not replenish her inventory of clothes and her business

suffered. Forced to come to the flea by bus, she could only bring what would fit into a suitcase. But others at the flea helped support her.

I was once talking to Eve when a man in red corduroy pants and horn-rimmed glasses, his hair lacquered back over his head, dropped off a painting and an envelope of money. She told me that the man, Bobby, would purchase paintings at a "secret auction" in the flea and then give them to her. The paintings were often worth thousands of dollars. The paintings and money were a gift. As we spoke, an octogenarian wearing all denim, his head radiating two vertical spikes of gray hair, dashed in to give Eve a kiss on the cheek. Before he left, he grabbed a *Playboy* magazine off one of Eve's tables. "Evelyn Waugh," he said quizzically, staring at the cover. "A present from a friend," she responded, with everyone understanding that it was from Paul the haberdasher.

. . . .

AT THE FLEA, vendors did not want to sell an object not knowing what it was, for it could have been of great value; nor did they want to sell something for a lot of money when it was a forgery or was painted by an art student who, as a class exercise, was copying the style of an important artist. Getting authentication was time-consuming, and in the case of those buying from abandoned storage units and thrift shops it was almost impossible. Few experts, however convinced they are of the correctness of a work, would authenticate an object that had no history; also, many experts are

contemptuous of flea vendors and pickers. So vendors needed someone they could trust to tell them whether a painting was worth $25 or $25,000.

And that person needed to make the decision in minutes, not days. People constantly came through the flea offering items to the vendors. These sellers could be pickers, who came with trucks full of what they had bought during the week, or someone who had just inherited a rug from grandparents. The vendors knew that if they passed on the offered items, the seller would continue to the next vendor and the vendor after that until the item was sold. So the vendor had to make snap decisions, often given no more than a minute or two to decide whether to make a purchase.

At the flea, the person vendors trusted to give them a quick and solid second opinion was Frank. His booth was across from Paul's. According to the most sophisticated vendors and pickers, Frank had "the eye"—though he had no formal education in art history, having never worked at a gallery or auction house, Frank seemed able to know the truth of what was presented to him. Objects and people opened themselves to Frank in ways they did to no one else.

Frank was also known throughout Brooklyn and Queens as the person who would buy things no one else wanted, objects rejected by the companies that were in the business of buying and selling local estates: used clothing, mixed lots of tableware, clocks with cracked faces, the shattered stuff that ended up in basements, garages, and dumpsters. But once inside your house, Frank, the clever, winning Frank, Frank with the Italian accent, the old sports coat, and pants

belted well above his waist, would convince you to sell him something that you had never thought of selling, something old and intact. Something you kept in the bedroom or on the mantel in the living room and was too dear to you, or just too dear, to consign to an estate company. So Frank would end up taking much away that was not broken, dirty, or cracked.

Frank sold objects ranging from trinkets to Old Master paintings. His method of transferring these objects to his booth at the flea was to toss them into a large box and then empty the box onto his table in the garage. Upended and unsorted, they formed a collage. The next week all objects, minus those that had been sold, would be redistributed on the table into a new construction.

Frank grew up in southern Italy and retained the quick smile, accent, and gestures of that place. At some point, he lost his thumb. He came to the United States after the war. He worked at various jobs around New York but his persistent interest was art. He went to museums, churches, and public parks, wherever he could encounter paintings, sculptures, and murals that moved him. When he started cleaning out homes and buying estates, he was able to identify immediately the objects of value. By the time I met him in the flea, he was in his seventies.

Knowing that regular buyers at the flea, especially pickers, would always stop at Frank's booth to say hello, people who had expensive antiques or paintings and did not want to go through auction houses or galleries would ask Frank to sell them on consignment. Frank would do so, but for those

customers in the flea who regularly bought from him and for those he liked, Frank would indicate, in a set of gestures he brought with him from Italy, what he thought of the item. An index finger below his right eye meant that the object was probably not what the consignor claimed and that you should proceed carefully; the same index finger to the upper side of his head suggested that the item was probably genuine but that the price was crazily high; but if Frank brought a fist to his mouth, kissed it, and then opened it quickly, you knew that he thought the item was authentic and priced well below its worth.

There was always a flock of people in his booth: regular customers who delighted in the hunt through his tables, and women who, young and old, found Frank invigorating. And Frank, in turn, was happy to entertain them.

The exchanges with these women were conducted through a kind of theater that Frank improvised in his booth. His accent meant that his English was full of emphatic consonants and a tendency to mix up gender, though the latter may have been slyness on Frank's part.

From across the aisle, Paul witnessed it all.

"Frank is a troubadour," explained Paul. "He seduces women with his stories and songs, but he does it not just for himself or the women but for the rest of us, who are forced to spend our weekends here. You'll see."

And I did see, for if I was in the flea when Frank began one of his performances, Paul would make certain to find me.

One Sunday afternoon in late spring, just before the garage was closing, a well-dressed middle-aged woman with red

hair and navy-blue dress entered Frank's booth. Paul knew what was coming and found me. He and I returned to his booth, where we watched.

Frank cast himself in the role of a young Italian soldier and the woman as the marchesa he loved but who did not love him. He confessed and cursed the passion that her beauty had inflicted upon him and that she, married to another, refused to return despite the jewelry (at this Frank drew a handful of costume necklaces from his table) and the fine robes (Frank gestured toward the racks of clothing at Paul's) that he had given her.

But before the woman could respond, Frank announced, "There can be only one end to this." He grabbed a knife from the table and held it against his neck.

The woman, drawn into the drama and staring fixedly at Frank, gasped and grabbed the knife. She pulled it away from his throat. He drew it back. They struggled. Then they stopped, silently gazing at each other.

Before leaving his booth, she returned the knife to Frank. She also looked to see if anyone in the garage had witnessed what had happened. Her eyes met Paul's.

" 'Since it no longer pleases you that he loves you,' " Paul responded, " 'you have killed him and he is happy to respond with death.' "

The woman exited.

Paul returned to his egg sandwich.

There was speculation that Frank, who was married, had lovers, that some were young women and some old and that some were men who dressed as women. Then again, there

was much speculation about Frank: how he had lost his thumb, where he lived, whether he was happy or unhappy. Frank did nothing to suggest that any of the rumors were right or that any of the rumors were wrong. And each week he allowed more to accumulate. So they grew, like the objects on his tables, into an enchanted collage.

It was not only customers who came to Frank's booth. Frank was also the person to whom all vendors came if they needed personal help; and it was Frank who figured out how they could be helped. Many vendors in the flea could not afford insurance; if one of them got sick and Frank knew about it, which he almost always did, he would approach the other vendors to help out. If someone came to thank him for his assistance, he would wave them away.

Through his interventions, Frank built a group of people—those who inhabited the lower level of the garage— who came to trust and depend on each other. And if they fought, Frank was there to calm them and remind them of their concern for each other. The Mayor of the Flea was his moniker.

. . . .

THE BOOTH TO THE NORTH of Frank belonged to Carol, a middle-aged woman who sold neatly displayed and mostly expensive paintings. Carol's nails were painted the lightest and most ethereal pink, and her short hair was parted on the side and dyed chestnut. Her scarves were tied in a Parisian knot.

Unlike the other vendors, Carol prided herself on having

a scholarly knowledge of artists. She had only begun selling art after her husband died. Living in the suburbs, her two sons in private school, she sold whatever furniture she did not need from her house and with that money began buying and selling art. As she told the story, her degree in art history from a prestigious college, several years at a top auction house, and her continuing study of writing about art gave her an edge over her competitors.

Now, many years later, she had made a great success of herself as a paintings dealer; so much so that she was able to retire. But each weekend she came to the flea because she liked the people there. Next to the chair where Carol sat was another chair, and she invited visitors to her booth to sit and discuss the works she was exhibiting. Often I would find Carol sitting with someone she later told me was the curator of a museum or a prominent collector or the head of a private club who was looking to deaccession paintings, quietly. Smart, knowledgeable, and possessed of the best manners, Carol was someone you could trust.

As a regular at the flea, I would make a point of stopping to talk to her. It was during one of these conversations that another woman, who had a booth in the flea but whom I had not yet met, called me aside. The woman's skin was a darkish brown and she had long, graying hair. She was dressed in khaki pants and wore no makeup or jewelry.

She had something urgent to tell me.

She motioned for me to move closer, beyond where Carol could hear. As I did, the woman bent toward the side of my face.

"Don't buy anything from that one," she said, referring to Carol, "and don't give her anything. She doesn't make good on what she owes."

The "don't give her anything" was a reference to the fact that some of the vendors in the garage like Frank would take objects on consignment. Carol did so. She would charge a percentage of the sale.

The material consigned in the flea was typically what one would find in an upscale retail store, antique stop, or auction house but had suffered some injury. A scratched ceramic plate signed by a known ceramicist, perhaps, or a Baccarat ice bucket missing a handle, etchings by Piranesi with extensive foxing, an original but torn movie poster by Saul Bass, silver platters by Tiffany with dedications to retiring vice presidents engraved in the center, nonworking nineteenth century pocket watches, oriental carpets with holes, a French club chair from the 1930s saturated in cat urine . . . Usually the cost of correcting the problem exceeded the potential value of the object.

The woman glanced behind me and then to the side.

"There are dangerous people here."

She glanced back at Carol.

"They look friendly; they pretend to be trustworthy, but you must be careful. Under no circumstance trust her. *Ladrón*."

But it was she who seemed questionable. Paranoid, officious vendors like this woman, Carol often told me, gave the flea market a bad reputation.

Carol, walking toward me, called my name. She was unaware that the woman had been speaking of her.

"Lovely seeing you," Carol greeted the woman.

"Would you mind watching my booth?" Carol asked me. "I am going for a coffee. If either of you would like something, I am happy to bring it back."

We both declined. I did, however, agree to sit in Carol's booth and having done so left my conversation with the dark-skinned woman, who returned to her own booth. But every so often I would catch her sizing me up. When she finally nodded, I knew that she had decided I was exactly what she had been waiting for—an agent in the camp of her enemy.

· · · ·

As I became more familiar with the vendors, it was not uncommon for them to ask me to sit in their booths, as I had done with Carol and Paul, while they ran an errand, had lunch, or transacted business in some other part of the flea. I came to enjoy meeting their customers.

At Carol's that day, several people strolled in. Some asked questions about the paintings, to which I gave the same response:

"Carol will be back in a few minutes. I'm just looking after her booth."

And then a large man in a blazer and sporting a beard, after examining several of the paintings, made his way to my chair.

"Do you know where Carol is?" he asked. He evidently had not heard me tell the other customers that Carol had stepped out and would be back shortly.

"She went to lunch."

"You work for her?"

"No."

"Related to her?"

"Not at all. Just a friend."

That seemed to satisfy him. I returned to my sandwich. I had, owing to my time with Paul, begun to buy my sandwiches from Johny's.

Suddenly I was having trouble swallowing. But it was not the sandwich. Fingernails had stapled my esophagus—and they belonged to the large man.

While I choked, he held my throat and looked around Carol's booth. What he was searching for was unclear. I had heard stories of people stealing from vendors or threatening them with knives if they refused to hand over money. Often thieves worked in gangs, with one person distracting the vendor while an accomplice walked off with something valuable. If vendors caught them, they would chase them down and sometimes beat them with a bat or tire iron.

With his free hand, the large man tore away the cloth that hung over one of the tables. It was there, underneath the table and behind the cloth, that Carol kept her purse. Carol always had a significant amount of cash, and the man seemed to know that. But Carol had taken her purse with her, so there was nothing under the table.

"Fuckhead!"

My assailant's face was so close that I could smell his beard. I'd managed to find my breath, but was still gasping.

"Tell me where she is," the large man demanded. "She owes me for the paintings I gave her."

I did not know where she was, and had I known, I probably would not have told him. Carol was a friend.

"Let go of him," I heard from behind the large man.

Frank had appeared on the other side of the man. My attacker, though a good decade younger than Frank and certainly taller and fitter, sensed the potential brutality in this small, soft-spoken Italian without a thumb. The light in Frank's eye, which to women was a twinkle, was to this man the glint of a knife.

"Tell Carol to go to hell," the man said, releasing my throat and storming down the aisle.

The dark-skinned woman watched all of this from her booth. It was she, seeing the man grab me, who had alerted Frank.

Now she was at my side.

After making certain that my assailant had left the flea, I thanked her. She invited me into her booth, where, she promised, she could share a thermos of tea. Her name was Sophia, she said.

• • • •

LATER THAT DAY, having recovered from the shock of the assault and assured myself that Carol and her purse were safe, I went to see Sophia in her booth. Her items were few, but they were exceptional: a hand-woven prayer rug, a lacquer

box, an abstract wooden sculpture on an ebony base. The sculpture, like so much in the flea, was presented without explanation. That is, nothing as to who might have carved it or when—nor where it had been prior to its appearance on the dealer's table. Even when explanations are provided in the flea, they are cryptic: "It came from a nice home" or "I was told that it was old" or "I can't remember where I bought it but I've had it for a long time."

From this, one may interpret the object in a way that a fuller explanation or more coherent setting would not allow, and this gives the imagination an enlivening license.

This particular object I knew. In the shape of an upside-down question mark, it was presented by Sophia as a sculpture. But it was originally used in rural Japanese homes as a hook from which to suspend kettles and teapots over fires. The Japanese word for such hooks is *jizai*.

Given that this hook was from the nineteenth century, it should have been charred and broken, but it was solid, with a luminous brown patina.

My time with the *jizai* was interrupted by Sophia.

"My grandmother was a Venezuelan aristocrat. I grew up in her house. There were servants and tutors and farmhands. When one died, they were replaced by their children. The other side of my family was Prussian. My great-grandfather was an advisor to Bismarck."

"Were you happy in your grandmother's house?"

"Not really. Everything was about manners and proper schooling for a girl: how to draw, play the piano, address the

servants, read Virgil in the Latin. None of the women were expected to have careers, and all of us were to be married to men chosen by our families.

"I came to the United States to escape this. When my grandmother passed away, my mother and father withheld the land which my grandmother had left me. It was their way of punishing me."

In New York, she met a man named Umberto.

"He was not wealthy, but his grandfather was a friend of Garibaldi. Umberto's father left Italy when he was still young. He traveled to South America and then Cuba, where he lived for several years. When he moved to the United States, he settled in New York. His father was a dealer in Italian furniture, especially Baroque, the sort inlaid with ivory and tortoiseshell, and Umberto shared his interests."

Soon after Umberto and Sophia met, they married, and soon after they married, they had a daughter. Umberto and Sophia, with their fondness for antiques, began to buy and sell them. Success arrived quickly at their shop, and they opened a store on Fifty-Seventh Street, next to one of the auction houses. Many decorators came to their shop. Also, curators, antiques dealers, and men and women with large apartments.

But difficulties arose. There were problems with the economy, and though certain decorators continued to buy from them, there were not enough other customers. Also, their young daughter was beginning to have problems with her abdomen. She needed doctors. Between the doctors and

other expenses, Sophia and Umberto could no longer afford to pay the rent on their shop.

Sophia and her husband knew of the flea market in Chelsea and began to sell antiques in one of the open parking lots in order to meet expenses. After a couple years, they took a booth in the garage. With the money they made from the flea, they supported themselves and paid medical expenses for their daughter, who continued to suffer abdominal pains as she grew to be a young woman. She told her parents, "I am being sliced open from inside." When I first met Sophia, her daughter had been operated on thirteen times, with each operation removing more of her. A year later, all of her intestines were gone.

Sophia heard of doctors in Europe who were developing a cure for her daughter's illness, but it was not covered by insurance, and Sophia and her husband could not afford the trip and the treatments. Only morphine relieved their daughter's pain and only some of the time. Sophia and Umberto became attached to the people in the flea in a way that did not seem possible with the gallery owners they'd met on Fifty-Seventh Street. Sophia told stories about how, when she and Umberto were in need of money, Paul would offer them money or give Umberto the gift of a warm overcoat to help him with winters in the parking garage.

One morning I entered Sophia's booth and found her staring into her lap. On that day, as on all other days, she was thoughtful, asking about other people and their children. But I discovered that her daughter had died. "My body is destroying me," she had said to her mother. "I need to

leave it." I would have expected to find Sophia broken and charred, but she was not. She was solid, with a luminous brown patina.

• • • •

HOWEVER MUCH TIME I spent with other vendors, I always made time for Sophia and Umberto. They were quiet and intelligent and the objects they sold reflected that. No matter how busy they were, they would leave what they were doing to talk to me.

Sophia was friends with Angelo, who sold frames next to Jokkho. Like Sophia, Angelo said that he was from an aristocratic background. He claimed he'd come to the United States when his father was appointed ambassador from Malta. Angelo was educated in art history but took a particular interest in antique frames.

Over the length of their friendship, Sophia, Paul, and Angelo, never more than a few steps from each other in the garage, shared their affection for art and exchanged stories of their upbringings in old and privileged families, perhaps none of which may have been true.

4

If you entered the garage at the ramp on Twenty-Fourth Street and then walked north, you would have encountered, in this order, Jokkho, Paul, Frank, Sophia, and finally Carol, before arriving at the ramp that led up to Twenty-Fifth Street. Directly underneath that ramp were large folding tables, and on top of those tables were glass cases filled with war memorabilia (French cavalry binoculars, rods to clean rifles, a Navy jumper, a Red Cross We Can Win poster) and late nineteenth and early twentieth century postcards. There were also books and magazines from the same period, many having to do with war and the military. Often there were religious books and old Bibles with velvet covers. And photos and letters and reels of home movies.

The swords, uniforms, and medals were on top of the tables, and the books, magazines, and letters were in boxes underneath. Collectors were not as interested in the letters as they were in the stamps on the envelopes. Those who collected stamps stood for hours going through the boxes.

It was here that I made one of my most prized purchases at the flea—a thirteenth edition of the *Encyclopædia Britannica*. It

was on the floor, underneath what I was told was a bullet-torn blanket from the First World War. First published in 1926, the thirteenth edition of the *Encyclopædia Britannica* is a landmark of twentieth-century culture, composed of thirty-two volumes and featuring original essays by some of the greatest thinkers and most important figures of the time, including Albert Einstein, Marie Curie, Sigmund Freud, Henry Ford, George Bernard Shaw, and Leon Trotsky.

Over the years, I'd read essays from the thirteenth edition—Einstein on "Space-Time," Ford on "Mass Production," Trotsky on "Lenin"—but I had never owned one. The paradox of such intelligence lying on the concrete floor of a subterranean parking garage was intriguing. So as well the relationship between the blanket and the books. I bought the books and the blanket. Bringing them home, I had no place to put them but the fireplace in the living room, arranged as they had been in the flea, with the blanket on top. Because it was summer, the books and blanket were able to reside there with no immediate threat of incineration.

The purveyor of these materials was a clean-shaven and likable man by the name of Alan. He was in his forties. He wore old jeans and white shirts.

While I was looking at the *Britannica*, a young woman sat on a milk crate nearby. She wore red stretch pants and a red checkered blouse. She was reading from an oversized Bible printed in braille. The pages were torn and stained. As she read, her palms filled with sweat.

I had come to Alan's to find a birthday present for a woman who was a film editor. The birthday party was that

evening, and I needed something quickly. Explaining that the woman collected rare films, I was interrupted:

"Stop right there. I have what you need."

Alan retreated to the far side of his booth and began digging through boxes. While he did so, I opened an envelope that was on the table against which I was leaning. Inside was a tattered volume titled *The Command of the Air*.

Alan returned, carrying three small film canisters.

"Your friend will enjoy these."

How to Sell a Vacuum Cleaner was written on a strip of masking tape stretched across the top of one of the canisters.

"I doubt she'll have this; low-budget, but excellent."

"And the price?" I asked.

Alan ignored the question.

I loosened the top of the canister.

The film was thinner than I'd expected.

"Eight-millimeter," Alan said. "If your friend doesn't have the projector for this, I have one in storage."

"Expensive?"

"Yes, but it's worth it. If she doesn't get the projector, she won't see the film. If she doesn't see the film, you've wasted your money, and your friend, your dear friend, sits with the film on her kitchen table, thinking what a piss-poor gift you gave her."

Alan handed me a second film: *Dark Chocolate*.

"They're from a friend's library. If you like these, there are others. *Dynamite Chicken*. Have you seen it? My friends in it. Along with Tuli Kupferberg."

"I don't believe so."

I inquired as to how many films were in the collection.

"Dozens, maybe more. If your friend the editor is interested, she can have them all. One problem. Many are in foreign languages. Mainly Swedish, but some in Japanese and three in Romanian. The ones in Romanian are especially fine. If your friend doesn't speak Romanian, I have dictionaries. You're getting something very special, very intimate—the personal film collection of Al Goldstein—and if you get the films, the projector, and the dictionaries, I'll give you a good price."

"Al Goldstein, the . . . ?"

"None other."

When I first moved to New York, Al Goldstein was publishing *Screw* magazine and hosting a late-night public access television show, *Midnight Blue*, with a regular feature called "Fuck You."

"Is he still alive?"

"As far as I know."

"And he's okay with you selling these?"

"Only to the right people."

I agreed to take the entirety of the collection.

Before leaving, I held up the envelope that I'd found on the table.

"My compliments," Alan exclaimed. "You picked the most valuable item on the table. The book inside is a military classic, though very few know it."

"Where did you get it?"

"Goldstein."

Of course.

Alan (and apparently Goldstein) was a scholar of military history.

"The airplane had barely been invented," Alan continued as I paged through the book, "when the Italian who wrote the book—his name was Douhet—predicted that one day planes would carry bombs and that the country with the most bombs and fastest planes would rule the world. All you had to do was drop them on civilians. Day or night, whenever they weren't expecting them. That was the key.

"Everyone thought the guy was nuts (which he probably was) and they locked him up—so this man, this genius, sat in jail because society didn't understand him. Just like Goldstein. But his writings got out to the Germans, who were smart enough to appreciate what he was saying, and next thing you know they're bombing civilian populations in Guernica and then Warsaw, Paris, London. That book you're holding was probably held by Goering, possibly even Hitler. Hitler loved the guy."

"The book is in English," I pointed out.

Alan did not hesitate.

"Look, you're a good customer."

So far I wasn't even a customer.

Alan gave me a friendly slap on my shoulder. "Did you ask me the price of the book?" It hadn't occurred to me.

"Don't worry. We can work something out. Especially if you get the encyclopedia, films, projector, dictionaries, book, and typewriter."

"Typewriter?"

He lifted an old Olivetti off the shelf.

"I can't say that this works, but it may just be what the Italian used to type that book. An expert could tell you. If you like, I know one."

I needed no expert.

Alan was my expert—on Al Goldstein, military history, and typewriters—but more importantly on the current that ran between objects. And I knew from Alan that walking away with an eight-millimeter film, a rare book, or an Italian typewriter would not disrupt that current, for Alan quickly filled the empty spaces with other esoteric conductors, restoring the connection and electrifying those who came into contact with them.

While Frank had revealed the transforming closeness a vendor might have to the objects on his table, Alan suggested this was part of a larger phenomenon: that objects, randomly assembled and of different kind, form an ecosystem of proximate items that define the objects in a way that is unique to that system and thereby remove them from the cage of their genus. There was something freeing about this idea, and I began to purchase objects at the flea that had no real value in their own right and were not part of any collection but were simply linked to vendors I knew at the flea and to the seemingly unrelated items surrounding, defining, and sheltering them.

Under the spell of this, I felt compelled to buy and bought the thirteenth edition of the *Encyclopædia Britannica*, its protective blanket, and the films, and the book, and the typewriter. It was as if they were not separate objects but a single one to which I too belonged.

. . . .

ON MY SUBSEQUENT VISITS to Alan, I could not but notice the African masks and statues neatly displayed on the tables in the booth next to his.

Growing up, I had an interest in Africa and had taken several courses in African politics and history at university. After college, my plan was to move to Africa, but all this changed when fighting arose in the country that I had chosen. It was not surprising, then, that I would find myself intrigued by the objects in the booth next to Alan's. There was no one there except the vendor, who introduced himself as Ibrahim Diop. He was in his thirties, and he was from Mali, specifically Bamako. His rich brown skin appeared to be underpainted in a cherry-red, and he had a quiet smile and eyes that seldom strayed from those to whom he spoke in his informed but never pedantic way.

Ibrahim sold masks, hats, and sculptures from various parts of West Africa, chiefly Mali, Nigeria, Ivory Coast, and what was then called Zaire (now the Democratic Republic of the Congo). Next to these on the tables were baskets filled with jewelry from these countries, and on the floor below were stacks of cloths in bold and abstract patterns. The most striking color was the blue from the indigo plant, which I learned from Ibrahim had been applied to the cloth by women from the Mandinka tribe of Mali. They had been taught their skills by earlier generations of women. The designs and process of dying were also influenced by techniques brought to Africa from Japan. Near the cloths, Ibrahim placed half a

dozen carved wooden seats. These, Ibrahim explained, were milk stools—chairs low enough to allow a comfortable place from which to milk a cow.

An indigo cloth hung over a string at the back of the booth. There was enough room between the cloth and the wall of the garage to provide Ibrahim and other Muslim vendors a place to pray, out of sight of those passing in the flea.

The booth was never crowded. In fact, I rarely encountered anyone else in it. Because people came to the garage expecting to find vintage clothing, furniture, silver, and tools—not sculptures of miniature human figures perforated by nails, not hats constructed of two-foot-long orange feathers—visitors to the flea seldom entered Ibrahim's booth.

People may also have stayed away because African dealers had the reputation for selling "fakes." While that is a term with a relatively clear meaning in the context of Western art, it is less clear when applied to African artifacts. There are two possible meanings of "fake" in this context: either the object was not as old as represented by the dealer or the object was made for the tourist or foreign markets and never used in tribal ceremonies. Both definitions are problematic. Traditional African works are often constructed of wood, raffia, shells, feathers, mud, and other fragile materials. Because of this, and because they are used in ceremonies or exhibited outside, few objects last decades or even years. An African sculpture that predates World War II is considered old.

Also, in the traditional tribes of West Africa less importance is assigned to the age of a sculpture than to its effectiveness in achieving the ends for which it was created. A

sculpture made last month may be of greater value, owing to its power, than one that is much older. While some of the objects sold by African vendors at the flea were surely made for foreigners, those objects might have been made by the same artists who created the identical object for the tribe.

There is one other possibility, which is that the African vendors in the market were lying about the age, origin, or use of the items they were selling. But I never knew Ibrahim to misrepresent an object, and among the other dealers in the flea he was well liked and respected.

One way Ibrahim distinguished himself in the flea was his openness to bargaining. The initial price given by Ibrahim for a sculpture or mask was often far above what he was willing to sell it for. He expected to bargain and appeared to enjoy it. Often the bargaining took place over coffee or man-cala, a game played by Ibrahim and his friends on a wooden game board set up in the booth. The bargaining could extend over two or three weekends.

This was different from most of the other vendors in the flea. Paul, the silver-haired haberdasher, believing his prices to be well under what a customer could find elsewhere and finding money an objectionable subject of discussion, never negotiated. He could go into a tantrum at the mere suggestion that he reduce his price. Jokkho, the guardian deity of the flea, priced according to his ever-fluctuating moods if he priced at all: in a good mood, he gave items away; in a less than good mood, he would refuse to sell anything. Most other vendors extended an immediate small discount to anyone who asked for one; and for friends or particularly good customers, they

further reduced their prices, though rarely beyond 25 percent. Before buying from a vendor I did not know, I would listen to their negotiations with other customers to learn their preferences with respect to bargaining.

But Ibrahim was not always at the flea to bargain over his objects. Often he would disappear for weeks, if not months, at a time. During these periods, one of his two brothers would take over his tables. One sibling was the distillation of Ibrahim's serious, even academic side, while the other was the lighter, more talkative version of Ibrahim. What the brothers shared was an affection for each of the objects they sold and an appreciation of the spiritual differences between those objects despite the similarities in the artistry, traditions, and societies that created them. With the money they made at the flea, the Diop brothers supported their families, some of whom were in New York but most of whom were in Mali. With their wives and children, the Diops would sometimes stop by my apartment for tea.

The reason for Ibrahim's absences was that he divided his time between the United States and Africa, maintaining residences in both, and traveling back and forth to bring art to New York. Once in New York, the objects would be housed in a storage unit in West Chelsea. Ibrahim would select an assortment of objects for his tables at the flea. After a couple months, he would pack his minivan full of what he had not sold and drive across country, stopping at other flea markets and meeting with collectors along the way.

This was not without risk. Ibrahim was frequently stopped by police, who said that they suspected that his van carried

drugs or guns, not artifacts from West Africa. On several occasions his van was seized and only months later returned.

The term used to describe Ibrahim and other dealers who shuttle between Africa and the United States and then between cities within the United States is "runner." That is as misleading as "fake," and swells with no small amount of racism. Not only are Ibrahim and the others experts in what they are selling (an inherently complex subject), but they are often the second or third generation of art dealers in their families. A white vendor with a similar level of knowledge and experience doing the same work would not be referred to as a "runner."

Because of the way in which Ibrahim acquired and sold objects, there were always large bags of objects underneath his tables. Often the contents of those bags had just arrived from Africa. As I came to know Ibrahim and his brothers, I noticed that there was always one bag that remained closed. When I asked Ibrahim about it, he promised that one day he would show me what was inside. For months I would stop by his booth and enjoy what was on display—Bamana masks, Bemileke bellows, Yoruba brass sculpture, metal anklets and bracelets, beaded necklaces, Dan masks, terra-cotta heads from the Fante, Ethiopian shields, Dogon ladders, and Senufo beds. And when I was finished we would sit and talk over tea or coffee, negotiate prices while I lost at mancala. But the bag always remained shut.

It was not until a year after our first meeting that he opened it for me. What he extracted that day was a chimera—a creature with the body and snout of a hippopotamus, the single hump of a camel, scattered feathers, and triangular legs—yet

no eyes or ears, no tail or feet, and no mouth. It did, how-ever, have two anuses. Its surface was a thick, grayish brown crust of finely macerated materials of unknown age. Large and small fissures crisscrossed its hide as if something were erupting from within. The creature was engrossing yet no more than two feet high and three feet long. It was like noth-ing I had ever encountered or imagined, and I was fascinated.

Ibrahim told me that it came from Mali, and that it was an item of great ritual importance. He explained that animal bones and other objects are inserted into the figure's anus. I bought it and placed it in my home.

I returned to Ibrahim the next weekend and asked him if he had other objects of this nature. He did and brought them to me at the garage on weekends and then during the week to cafés in Chelsea and my apartment at the hotel. I spent hours alone with these objects. What distinguished them from other objects Ibrahim sold me was that they were vessels for the spirits of the tribe, and as such were treated as alive. Masks, sculptures, and headdresses would be used to call spirits to a ceremony, but these other objects—referred to as *boli*—were themselves infused with the spirit and thus godlike. As such, they had a special status within the tribes that made them.

Boli are often referred to by collectors, as well as those who have written about African art, as "fetish figures," "fetish objects," or just "fetish." Some believe that the word "fetish" had its origins in the clash of European and West African cultures in the fifteenth and sixteenth centuries: To explain why Africans would assign such high value to

objects that Europeans found worthless or repulsive, Europeans theorized that Africans—being supposedly too barbaric to comprehend abstract concepts such as randomness or God—would use the objects to understand what they experienced. These objects also allowed members of the tribe to believe that they had control over these experiences, for the fetish could be destroyed and replaced with another.

While the boli I was initially shown by Ibrahim were roughly in the shape of animals, others looked like humans, and still others were entirely abstract. Some boli had the heads or stomachs hollowed out to hold special substances; some had mirrors to reflect away evil or to blind hostile spirits; some had multiple heads or additional eyes to ensure protection; others held spears.

The boli I first saw in the garage was connected to the Komo Society of the Bamana, a secret association of tribal members that is the authority on the construction and use of fetishes. The boli assisted the tribe in achieving various goals—perhaps the destruction of those who threatened the tribe, or protection against disease, or the punishment of individuals who undermined the society. To activate the boli, a member of the Komo induced a local spirit to enter the fetish. The organic materials of the boli and the deity that enervated it became indistinguishable.

Boli are traditionally constructed from a variety of materials. Inside the boli is a skeleton of wood wrapped in cloth. Over that frame, depending on the boli, may be layered mud, feces, horns, shells, nails, feathers, twine, paint, raffia, fur, beads, or herbs. The outer surface of the boli is comprised

of the dried fluids regularly poured over it to feed and placate the spirit; those fluids include menstruation, blood from sacrificed animals, saliva, chewed kola, honey, and urine, leaving striations across the sides of the fetish. The sacrifice of chickens and goats over the top of the boli causes feathers and hair to gather on the surface.

Some scholars have pointed out that the boli is a human turned inside out: the materials on the inside of the boli, such as the cloth, are what would be found on the exterior of a human, while the blood, feces, and bone on the surface of the boli are located in the interior of a human.

Whatever its ritual or anthropological significance, the boli—bones encased in earth, washed in blood, and inflamed by the spirit of a god that resided within—was a stunning alloy of life and death.

. . . .

A WEEK OR TWO after I'd taken my first boli back to my apartment at the Chelsea Hotel, Ibrahim knocked on my door. The hour was near midnight. He apologized for the late visit but he felt he could not wait.

"You know that I'm Muslim," Ibrahim said. The greater part of Mali was Muslim, though there was a historic tolerance of traditional African beliefs, many of which have been integrated into Islam as practiced in that country. In certain parts of Mali, that tolerance had begun to erode. "So I do not practice the tribal religions," he added. "But if I were you and I had that boli in my house, I would feed it and feed it quickly."

This raised the question as to what it ate.

Ibrahim explained:

"The blood of bleeding women."

He was, I was pretty sure, referring to the blood of women having their periods.

"Do you know any?" he asked.

"A couple come to mind, but it may be a little late at night for that sort of thing."

"You should call. They can take their turns feeding it."

The women of the tribe, Ibrahim explained, would kneel over the boli and saturate it with blood and urine.

My wife, who was traveling in central Asia, might have some ideas. I phoned her, apologizing for the time of the call but explaining its urgency.

This was the first she'd heard of the boli needing a regular nightcap of menstrual blood.

"Let me ask you," my wife began. "Do you really want to host a room full of menstruating women?"

"Good point."

"Is there anything else?"

If there was, I'd decided to keep it to myself.

I returned to Ibrahim. He was watching the boli.

"Is there something else that it might enjoy?" I asked.

"A small goat or large chicken. I'll hold it over the boli and you slice off the head."

"What about me holding and you slicing?"

He dropped his head in disappointment. I obviously had no understanding of how the ritual worked.

"Fine," I said. "You hold and I'll slice."

With that settled, there was still the question of where we would find a goat or chicken in the middle of the night.

"What about someone in the hotel?" Ibrahim said.

"There are rumors that a neighbor down the hall has a chicken, but he goes to bed early."

I asked Ibrahim if he had any other ideas.

"The Cowboy," he said.

I knew no Cowboy.

"Short man, cowboy hat, black shirt, black pants, bad leg." Still no.

"Never mind," Ibrahim continued. "I'll call him. If he's around, he'll help."

The Cowboy didn't pick up. Ibrahim left a message. We waited for an hour, but, not hearing back, Ibrahim returned to his family, and I to my bedroom, locking the door to the living room.

When my wife returned a week later, she insisted that the boli be removed from the apartment. She was convinced that it was moving in the evenings and would become even more mobile should she decide to feed it. The following afternoon, I phoned the Brooklyn Museum, which had one of the most comprehensive collections of African art in the country. They agreed to take it.

Sensitive to my disappointment over the loss of the boli, my wife and her brother, who was visiting from St. Louis, approached me one night over dinner. If I were to purchase another boli, they would feed it with their own bodily waste. The only problem with this, my wife's brother noted, was that if anthropologists were one day able to re-create

the tribal village from the DNA left in the boli, they would discover "dozens of Bamana and two Jews from St. Louis."

What was remarkable to me about these boli was how immediately and potently their forms suggested the power of the divinities that were said to inhabit them. I bought a great number of boli, filling what little room I had in my apartment. These boli were less mobile and required no feedings.

· · · ·

I'D ENTERED THE GARAGE with the idea of repeating what had happened in that garage in St. Louis—the discovery of something of great value. In the random and mostly valueless accumulations of Jokkho, Frank, and Alan, I'd found a self-defining community of objects and people and had begun to bring home scores of those objects every weekend—damaged paintings, worn rugs, pedestals, decorated wooden boxes, used linens and clothing, books—owing largely to their association with this society. To this I was adding, by the day, African objects I bought from the Diops made of bones, excrement, feathers, and spirits. After several years at the flea, my shelves, walls, windowsills, the mantel over my fireplace, and the fireplace were filled with these objects.

People referred to me as a "collector." I was that, surely, but I had become something more. I had progressed from passerby to a person of the flea, and to the extent that I collected, my gatherings—objects, friends, and thoughts—were an outgrowth of the flea and my life there.

Part II

A MYSTERIOUS
PAINTING

5

AT ITS HEIGHT, THE FLEA TOOK OVER, OVER-
whelmed, the area above Twenty-Third Street between
Sixth Avenue and Broadway. Open parking lots, garages,
old office buildings, and sidewalks were filled with ven-
dors, their tables, goods, and vans. Shuttling between these
were tens of thousands of people—pickers, vendors, and
customers—along with the men who loaded and unloaded
the goods into the booths, vans, and cars. Restaurants and
cafés served the crowds and provided a place for pickers to
do business. So large was the flea that one could not pos-
sibly get to every vendor in a weekend or even two week-
ends. And just when you thought you knew all the vendors
and what they were selling, a new location would appear. A
Russian Jew named Morris opened one of these when the
flea was near its zenith.

A rotund man with short light hair and a beard trimmed
every third week by the Uzbeks at the barbershop on Twenty-
Third Street, Morris took over the ground floor and base-
ment of a building that once housed a garment factory. He
divided the floor into fourteen spaces and rented them to

sellers of antiques and other exotica. Morris had no interest in these objects; he did, however, have an interest in collecting money, and this seemed to be an easy opportunity to add to his holdings.

One of those to whom Morris rented a space was Yitzhak, a Jewish man in his eighties, who sold religious books, mezuzahs, and antique Torah breastplates. Next to Yitzhak was a gentleman from the Philippines. He was raised on the island of Sibutu and offered artifacts from Sibutu and its surrounding islands. He explained to me that Sibutu was unusual in that when the Philippines was transferred to the United States by the Treaty of Paris, an unintended omission in the treaty left Sibutu and Cagayan de Sulu (now called Mapun) under Spanish control, where they remained until the beginning of the twentieth century. This, he claimed, caused these islands to develop a different culture and thus different art forms than what one found elsewhere in the Philippines.

I was first drawn to the man's booth by a weathered wooden figure from the Bajau, a nomadic people who move about the seas of the southern Philippines. When a member of the Bajau died, he or she would be brought to land to be buried. The grave would be marked with a carved wooden figure, with the bottom of the figure stuck in the ground and the top exposed. For this reason, older grave markers, such as the one in the booth, were rare and quite worn down, many to the point that the facial features of the carvings were so smoothed by wind and rain that they were indiscernible and hence universal. The Bajau, like the Diops in West Africa,

demonstrated a continued attachment to tribal religions, despite having converted to Islam. These grave figures in the booth were not for sale. Other objects, clothes and jewelry and photographs, were for sale, but not the grave figures.

Next to the man from the Philippines was a blond fellow, who, though handsome, was obese. His manner and hairstyle were those of a much younger man. The man was from Krakow and his booth was devoted to homoerotic photographs from Communist Poland.

Morris, who liked the Pole, would come over to his booth, select a photograph, and then, holding it up in the air, say to whomever was listening (often just me and Yitzhak) that if one imagined the Pole one hundred pounds lighter, he would appear as one of the men in the photograph. This was the sort of intricate and amusing notion by which Morris relieved his own unhappiness. The source of this unhappiness was Morris's sense that he was destined for something more elevated than spending his days sitting in a warehouse with Yitzhak, the Filipino, the Pole, and me.

Unlike the garage and the open lots, Morris's warehouse was open during the week. For this reason, I was at the garage on the weekends and at Morris's during the week.

Morris sat at a big desk next to the front door, and when a customer entered, which was rarely, Morris would direct them to the appropriate booth. But mostly Morris would scribble numbers in a ledger he kept locked in the metal safe below his desk. Every so often Morris would receive a phone call, which typically involved shouting in Russian, followed by Morris tossing down the phone and more writing in the ledgers.

While his vendors seemed to generate little income, Morris appeared to be well off. His wife and daughter would stop in once a month, dressed in fine clothes and jewelry, and always on their way to a store. Some suggested that Morris's operation in the warehouse was a means of explaining income that came from sources other than Torah pointers, salad bowls from the Philippines, and Polish pornography. I did not know.

While much was unknown about Morris, this could be said with certainty: he had no affection for art and less for the people who were selling it in his booths.

"They are not businessmen," he would scoff. "They're either sleeping or on the phone, and the Pole is too fat to fit into his booth. They hardly speak English, so how are they going to sell anything? And if they don't sell anything, how are they going to pay me? Explain that!"

After a few months of missed payments, vendors would sneak out, leaving Morris with what was in their booths. It did not take long before Morris had accumulated enough of this that he was forced to set aside a corner of the basement to store it. When that corner filled up, he expanded. Soon the accumulation filled the building's basement.

But something happened that no one, especially Morris, foresaw: the more time Morris spent with the objects the vendors had abandoned in the warehouse, the more interested, even enchanted, Morris became. He started to invite people who entered the warehouse to a viewing of what he'd assembled in the basement. And because many of the vendors had relied on Morris to translate their negotiations,

Morris had picked up enough knowledge of these items to put on a passable show of expertise.

Soon Morris was arranging the items according to dates and styles. Then he bought display cases and marble stands. Then he bought oriental rugs for the concrete floors, a green leather armchair, and a floor lamp. Morris, who was forever complaining about his tenants, complained less, talked about art more, and seemed happy.

He also started to dress differently. Paul, the haberdasher from the lower level of the garage, sold Morris a dressing gown and a pair of slippers.

The objects in the basement of the warehouse, the dressing gown, the armchair, and especially the slippers, had their effect on Morris. He no longer talked to people at his desk on the first floor of the warehouse; instead, he would invite visitors to his "gallery" in the basement, where he would put on the dressing gown and slippers, switch on the floor lamp, and discuss the latest additions to his collection.

"This bowl," he began with me one morning, "is what the Indians created before the Spanish arrived. Appreciate it, my friend. It just arrived, and it won't be here long. Notice the condition, the colors—as if they were painted yesterday."

"Morris, there's a sticker on the bottom," I interjected, pointing to a small oval label.

Morris lifted the loupe that hung around his neck and examined the sticker, though it needed no magnification. With his inspection of the label completed, he pulled the loupe from his eye.

"You think this sticker from an airport gift shop means

something! But you wouldn't think that if you'd been in the antiques business as long as I have."

If I remembered correctly, Morris's time in the antiques business dated back to Thanksgiving of the previous year.

"You would know," Morris continued, "that when something is of great value, like this bowl, it is going to be disguised as something else. The Mexicans would never let an antiquity such as this go if it weren't marked as something else. So this sticker means that the bowl is even more extraordinary than I thought. As to the price—"

Morris was interrupted by the arrival of his wife and daughter. From the look on their faces—gazing upon Morris in his dressing gown and slippers, sitting in his green chair surrounded by his collection—it was apparent that the idea of Morris as a fine art connoisseur had never occurred to them.

Morris's wife was the first to speak, pointing excitedly to the desk near the door, the desk where Morris kept his ledgers.

"What are you doing? Ivan keeps calling me, looking for you. And where are you? Down here? Dressed like a *feygele*! Go back to your desk and take care of business!"

Morris hung up his dressing gown, put away the slippers, and returned to his desk.

· · · ·

I LIKED MORRIS and continued to visit him despite his retirement from curating and selling the bric-a-brac in his basement. He was despondent and I offered what little consolation I could. One day, Morris handed me a key to the

basement and said I could enter whenever I pleased. Amid the lampshades and tablecloths that were part of Morris's collection, the rusted lawn chairs and boxes of glass jars, were paintings. Hundreds of paintings. Many were the sort that hung on the walls of restaurants. Many were reproductions of works that hung in museums.

Some were of great interest to me, if not terribly valuable. There was, for example, a small group of Indian miniatures. Morris knew little about them but claimed they had come from the estate of Oriana Fallaci, the Italian journalist and author. My decision to buy the miniatures, a category of art I'd never collected before but started that day, was triggered by the haphazard confluence of my relationship with Morris and his basement, my respect for Fallaci, and a superficial attraction to the images and colors contained in the paintings.

Morris's basement also had sculptures. People inherited art from their parents and grandparents, incuding marble busts from the nineteenth century, bronze leopards and horses for the mantel, wall plaques and terra-cotta figures from the 1920s and '30s, metal wall reliefs from the fifties and sixties. While such sculptural works may have fit comfortably into the homes or apartments of previous generations, they were too large for the apartments of those who inherited them. Also, they were often in a style unsuited to the tastes of those whose interests had turned to abstraction, minimalism, and conceptual art. Even renowned artists of the past could fall afoul of changing contemporary taste. William Zorach, for example, was a pioneering and celebrated sculptor who brought cubism and other modernist

styles to America in and around World War I. He died in 1966, yet his figural sculptures appeared in the flea for the price of a nice floor lamp.

Every weekday, I would head over to Morris's basement and use my key to open the lock. Unheated and cluttered, it was nonetheless a place of tranquility that came from the objects themselves, which, in this forgotten space, were released from expectation and order.

One day, in the middle of one of my excavations in the basement, I glimpsed the bottom of what appeared to be an abstract painting. Thick strokes of dark blue folded around a rub of crimson, which was set against golden yellows with a wash of gray. I was curious.

It took me a good deal of time to extract the painting from the heaps of other paintings and bric-a-brac on top of it in the stack. When I was finally able to see the rest of the painting, I was surprised. The excellent gathering of colors that had excited me about the painting were the bottom of a woman's blouse. That woman was the subject of the painting. Her hair was full and black and curly, her skin light, and her eyes were purple garnets. She leaned forward. She had stopped reading from a book that was still open on her lap. The book was large, perhaps a collection of poems or plays. Next to the woman was a cactus.

The impression of a simple portrait would not hold. There was something mysterious, even troubling about it. She seemed not to be reading to herself but to someone else, who remained unidentified. In her eyes was concern. There was also the matter of context. The artist appeared to have

purposely erased all clues as to where the woman was sitting with her book. So much so that the background of the painting was as abstract as the woman's blouse.

I walked upstairs and sat down next to Morris, who was on the phone. When he finished, I asked him about the painting in the basement.

"Excuse me," said Morris, holding up his hand. He opened the bottom drawer of his desk and blew the dust off his velvet slippers. After placing them on his feet, he began. "Done by a master in the middle of his most important period."

"Do you happen to know the master's name?"

"With my wife *shraying* at me all the time, I've forgotten. I think he was in World War II. He did this after he returned. He was in love with a woman—Frances—and he painted her."

"What about the person who sold it to you?"

"I forget his name. But he was a doctor who was moving to Florida. He had an office on Park Avenue, around Eighty-Fourth Street. An old man with a lisp."

"You remember the name of the woman but not the man who owned the painting?"

"Who forgets the name of a beautiful woman! Besides, it's under the mat of the painting."

By this time I was late for an appointment and asked Morris if he would hold the painting.

A day or two later, I returned.

And the day after that.

"Listen," Morris called to me from the first floor, "you want Frances, she wants you. So take her home, put her up,

see how you feel about her, and if you don't like her, bring her back. If you like her, you pay me later."

And so it was with everything I bought from Morris. If he saw any interest on my part, he would insist that I take what I was looking at home, knowing, of course, that I would never return the item and would pay him later. It was a gambit of vendors in the flea; once the object was in your home, you would become convinced that it belonged there, if only owing to the inconvenience of having to return it to the vendor.

But I had no more room in my apartment for additional paintings. Every wall was covered, every corner filled, and I had begun secretly to remove items, including kitchen supplies, towels, toiletries, and clothes I thought would go unnoticed, and replaced them with items from Morris's basement. In addition to the sculptures and paintings I was bringing home from Morris's, I had added frames. These were often overlooked in the flea, so it was not uncommon for a painting of little or no value to be in a frame that was worth hundreds of dollars. Certain pickers specialized in frames. To accommodate my growing collection of frames in a space where there was no space, I would hang them over smaller framed paintings.

Given a dilating concern over the state of my apartment, I left without the painting of the woman.

6

FOR PICKERS, WHO WOULD BUY IN THE FLEA AND then resell to a gallery, collector, or over the internet, the Chelsea flea was the most exciting, most profitable flea market in the country. The reason for this is that the concentration of art, furniture, and antiques in New York creates the chance that extremely valuable objects will, with some regularity, turn up in the garage or open lots. One of the paths these objects take to the flea is through the storage facilities in West Chelsea. When those who rent storage units fall behind on their payments, the storage companies auction off the contents of the units to a small group of individuals who are known to buy storage units and who, in turn, sell to the vendors in the flea.

Not long ago, the British journalist Anthony Haden-Guest discovered that his art collection had been sold off by a New York storage company when he was late in paying $1,350 in storage fees. The collection included paintings by the artists David Salle and Donald Baechler. A single painting by David Salle recently sold for nearly a million dollars.

Stories of treasures found in the flea were numerous: a

Picasso sculpture, photographs by Diane Arbus, a painting by Basquiat, a lamp designed by Giacometti, a counterproof by Degas—all purchased in the flea and resold at auction or through galleries.

Pickers in the flea had specialties—mid-century modern furniture and decorative objects such as lamps and clocks (anything by Dunbar or Cedric Hartman), china from Europe and America (Bernardaud, Limoges, Royal Copenhagen), vintage clothes (lingerie from the 1920s up to bustiers by Jean Paul Gaultier), hand-carved early-modern frames, Asian antiquities, silver and silver-plated flatware, art glass (Murano and Murano-like bowls and vases, vintage Baccarat, Lalique, and Orrefors), watches, stamps. One picker told me that she supported herself by digging through the piles of costume jewelry at the flea, knowing that in every pile there was a small but consistent percentage of rings, necklaces, and bracelets made of real gold or silver. She was so experienced at identifying real jewelry that she rarely needed the small testing kit she carried in her purse. Another picker hunted for broken vintage pocket watches. He knew an old Russian who could fix them; if they were missing parts, the man could make them.

Most pickers in the flea sought to avoid detection. They dressed inconspicuously and said little or nothing about themselves. They arrived with flashlights every Saturday morning between three and seven to be there when the vendors set up their tables. As soon as the vendors opened the trunks of their vans, the pickers, crowding around the vans, would shout out prices. Because of the competition, the pickers had to make decisions in an instant—often with tens of

thousands, if not hundreds of thousands, of dollars at stake. The more information the picker brought to these few seconds, the more likely they were to profit from the transaction or, at least, avoid making a mistake.

There was one picker, however, who stood out, and all vendors and other pickers knew him. He resembled in look and manner the prophet Amos, who was tall, thin, and given to relying on numbers (Amos began every speech with the enigmatic, "For three transgressions, even for four . . .") and dramatic gestures of his arms and hands. James Tissot's nineteenth century portrait of Amos, his arm extended outward, his index finger pointing sternly, was close to an exact match of the man. For this reason, the picker was known as the Prophet.

While other pickers looked for artists whose works sold in the medium to high range, the Prophet had no interest in such artists. He had no interest in artists at all. Picking for him was about dates and numbers. His approach was to memorize every major and minor artistic movement of the nineteenth and twentieth centuries, break those movements into periods—first generation, second generation, etc.—and then average the auction records for unsigned and undated paintings of those periods. Before the Prophet became a picker, he had worked as a psychologist in a local hospital. With a remarkable memory, he was able to absorb large sections of the *Diagnostic and Statistical Manual of Mental Disorders*. When he became a picker, he used this same power to absorb the volumes of auction records he had accumulated.

At the flea, the Prophet looked for paintings that had no signatures or dates—works typically ignored by other pick-

ers. When he found one, he bargained ferociously, making certain to get a price at least 50 percent below the average for an unsigned painting from the period. Because he knew that first- and second-generation paintings in each style were more desirable than later generations (regardless of the quality of the work), the trick was to date the painting without knowing the painter. Types of canvas, styles of frames, and the way in which stretcher bars were constructed provided a means of confirming the date of a painting as well as its country of origin, and he memorized the dates associated with each type of canvas, frame, and stretcher bar. This knowledge also allowed him the benefit of occasionally picking up a frame that was from a highly valued frame-maker at a price far below its true value.

The Prophet sold what he bought largely to interior designers and to those restaurants and retail stores in New York that needed delectable, eye-catching paintings for their walls but had limited budgets. For such art, authentication was seldom if ever required because it was assumed that forgers would not waste their time duplicating works without signatures and thus could never sell for more than a modest sum. Vendors did not have the time to absorb the information necessary to price these painting properly, so the Prophet was able to find what he sought on a regular basis. What this meant was that while others in the market could spend years trying to find a work worth $100,000 and then years more attempting, without success, to have it verified, the Prophet could, in a matter of months, accumulate a hundred paintings he could sell, on average, for $1,000 apiece.

During the week, when the flea was closed, he would walk through museums, absorbing periods and images and matching them in his mind to auction records. He would also fix in his mind the thousands of marks, monograms, symbols, and blind stamps artists used instead of signatures (James McNeill Whistler's mark was a butterfly; Carlo Crivelli's was cucumbers; Gauguin signed his works "P. Go."; Delft porcelain from the De Klaauw Factory was marked with a claw).

The other pickers viewed the Prophet as obsessive and possibly damaged by all of this, but nonetheless understood the singular nature of what he was doing. The reason pickers and vendors considered him damaged was that he would regularly halt in the middle of the flea and mumble numbers, not infrequently accompanied by a jerking of the hands and arms. They also viewed him hostilely because he voiced what others could not bring themselves to admit: that the flea was gradually disappearing and that this was a matter of numbers as well. As the profits per square foot of residences in Chelsea and the Flatiron District equaled and exceeded the profits per square foot of parking lots and garages, the flea markets would be razed.

"Prepare yourselves," the Prophet would admonish. "It will all end, and it will not help to go to the fleas on Thirty-Ninth Street or in Brooklyn. They too will pass."

When the Prophet was not buried in stacks of drawings and paintings at the flea or incanting numbers, he provided an ongoing diagnosis of those passing through the flea. "That fellow there in the khaki pants and tie," the Prophet would say, pointing toward someone in Paul's booth. "*DSM-5*. Paraphilic disorder. I've been watching him for years."

Or:

"Your African friends, the Diops. Do they know that post-traumatic stress in Africa is the highest in the world?"

Or:

"Harriet's husband only cares about money. But Harriet's not just greedy, she's dangerous. A sociopath."

But none of this was mean-spirited. It was delivered in a matter-of-fact, even constructive way. The Prophet saw a world of fissures and warned against them. What he could not understand was why he was spurned by others, why they might call him names and throw him out of their booths.

. . . .

As my collection of African fetish objects swelled, my passion for them diminished. I admired them, came to understand them in greater depth, and would not think of selling them, but I needed something else, though I did not know what. Ibrahim and his brothers had a fondness for art and would trade their objects for paintings, photographs, and sculpture. With many artists living in the neighborhood and coming through the flea, the Diops had assembled a nice collection of original art. When they needed money, they would approach me about purchasing those works. And so I began to buy from the Diops paintings and photographs.

At the same time, I was becoming interested in the small objects I found in the flea that were covered in enamel. The technique, in which a glass or a glasslike substance is fused onto a metal by heat, dates to antiquity, with the earliest known objects produced in Cyprus in the thirteenth cen-

tury BC. In the Middle Ages, caskets, reliquaries, crosses, and armor were enameled. The art form was highly regarded in the Renaissance, when portraits and wall panels were covered in luminous enamels. Though the technique went out of fashion, it was revived during the arts and crafts movement of the early twentieth century and again in the 1960s.

Late one Sunday afternoon, while standing in line at Johny's before entering the flea, I heard a voice from behind me.

"I'm told you're looking for me."

It was the Cowboy: a short man with a big cowboy hat, dressed in black, just as Ibrahim had described him. He had a long mustache, which Ibrahim had not mentioned.

The Cowboy was carrying an old satchel with a shoulder strap. The bag complemented his black jeans and western-style shirt and thick tooled black belt. The bag was two feet wide and a foot high. The leather was torn in places, the buckle was broken, and the stitching was coming apart. The Cowboy kept an affectionate hand on the bag, suggesting a long relationship.

"I needed a chicken but you're late," I pointed out.

"Is there something else you need?"

"I'm keen on enameling."

"I've heard."

The "I've heard" from a complete stranger reflected the velocity at which information, important and trivial, moved about the flea. A great number of the vendors and pickers in the garage had been together for decades, so information traveled quickly.

From out of his bag the Cowboy extracted a small metal object—a cigarette case, topped with an abstract design of overlapping squares and rectangles of orange, green, and red.

"Hans . . ." he muttered to himself as he stroked the case.

The ellipsis was even more intricate than the design of the case: the Cowboy was forced, it appeared, by the top of the case to invoke Hans Hofmann, who was an art theorist and teacher but also a respected artist who had painted overlapping abstract forms of bright colors. It was conceivable that Hofmann may have enameled the top of the cigarette case.

Without stating that the case was actually by Hofmann, but hinting at it, the Cowboy had made it impossible for me to consider the case without thinking that it just might be by Hofmann, and that meant that when the Cowboy finally announced the price, the cost did not seem so shocking.

"The eighteenth century was the great age of enameling," the Cowboy went on, while I continued to reflect on the price of the case. "They enameled everything: clocks, caskets, swords, bourdaloues, tables."

"Bourdaloues?"

"Named after a priest who gave long sermons. Women would come to the sermon with ceramic pots. When they had to piss, they'd slip the pot into their panties. I have a couple, if you're interested."

"Let's start with the cigarette case."

"Okay, but keep the bourdeloues in mind."

I examined the case and paid him for it.

"You won't regret this," he said.

Too late.

"Is there something else you're looking for?"

"Surrealist drawings," I suggested, guessing that this might be well beyond the Cowboy's offerings.

The Cowboy reached back into his bag, pushed his hand around a bit, and then, with the gesture of a magician, extracted a small pencil sketch in the manner of the surrealists and dated 1928.

"The surrealists loved flea markets," the Cowboy remarked.

"You don't happen to have a chicken in there?"

He didn't.

But he was right about the surrealists.

When the architect Georges-Eugène Haussmann, under the authority of Emperor Napoleon III, broadened and straightened the streets of Paris in the second half of the nineteenth century, many of the small merchants, scrap dealers, and ragpickers moved to an area in the north of Paris just below the gate at the Porte de Clignancourt. They were joined there by antiques dealers, and as the area became popular, aided by public transportation, small cafés emerged. This area came to be known as the "Marché aux Puces," meaning the "the Market of Fleas." Some have speculated that the term "flea" was derived from the bugs that infested the used furniture sold there. Others have suggested that the word described the transitory nature of such markets, moving like fleas from one location to the next.

By the 1920s, André Breton was walking daily through the Paris flea markets, which he refers to in *Nadja* and *L'Amour Fou*. Man Ray created sculptures from what he found in flea

markets, including the neck of a double bass. In the 1930s, the Paris flea was the site for flaneurs.

The attraction of the surrealists to the flea markets was understandable: conventional assumptions splinter under the weight of the randomness and inadvertence of the flea market, and in this way the flea was a dreamscape to these artists, writers, and musicians, one that evoked the danger and beauty of the unknown. With its deracinated objects and their unexpected juxtapositions, the flea awakened the mind to new impressions of the world. Table legs became sculptures and sculptures, table legs; doll heads were used for necklaces and the nibs of fountain pens for earrings; vinyl albums appeared shattered in paintings or were hung whole and alone as sculpture; carpets were made out of empty bullet casings; and gramophone horns were turned into hats.

This same atmosphere was found in the Chelsea flea, and it drew a similar crowd. But there was a difference: the flea market in Paris was its own landscape, which is to say that walking around the Paris flea, there was a sense that it was a secure kingdom. Not so with the flea in New York, where there were the surrounding grid and skyscrapers, a reminder to those in the flea of the abnormality and impermanence of their endeavor. That tension deepened the flea in New York.

I could not guess the Cowboy's age. His eyes were young, but his face was a field of intersecting lines. One leg was so badly damaged that he could only move slowly and painfully. Owing to his leg, he could carry only that small leather satchel.

Before I could complete my survey of the Cowboy, he turned and moved away from me as rapidly as his crippled leg would allow him.

"I am sorry," he called back. "I've got to go."

When I offered to walk him to his destination, he waved me off. I guessed that he was on his way to the secret auction that I had only heard rumors about, but rumors of the most solid sort. It was said that a private auction was held to which one had to be invited, and those who were invited were pledged to silence. Anyone caught talking about the auction would be expelled. As to who ran the auction, where it was held, and when, no one would say. The reason for the secrecy was that the auction was all cash, with no premiums added onto the price. There was another reason: what was sold there was consistently of greater quality than what was found in the flea, and because there were so few people bidding, it was possible to acquire unusually nice objects for a fraction of their value.

. . . .

ONE DAY I RECEIVED a call from the Prophet. He had to meet me immediately, he said. His voice was twisted by fear. We picked a coffee shop near the Chelsea Hotel.

As I arrived at the café, I was greeted by the Dane, a friend of the Prophet and fellow picker. He too had been called by the Prophet. The Dane was a tall, deep-voiced, and indisputably handsome man in his late thirties with a thatch of golden hair. He laughed frequently and loudly, he was given to inappropriate facial expressions, and he hugged people

with no invitation. Owing to a rubbery body propelled by enthusiasm, his hugs caused his body to fold around the person he was hugging, leaving the negative impression of the person on the body of the Dane.

The juvenile side of the Dane was joined by an allegro of insights, quotations, rapidly shouted questions, and wordplay that involved several languages. All of this revealed years of study, which he happily shared with the others at the flea.

Men were charmed by the Dane; women were more charmed. For this reason, he was not without companionship. He was also said to be a bidder at the secret auction of which I had only heard. If the stories were to be believed, and assuming the auction actually existed, the Dane would bid large amounts without ever inspecting the item and with no expertise. It was further said that others at the auction asked that he be banned but that the man who held the auction refused.

As we sat waiting for the Prophet, the Dane explained that the Prophet had recently come to believe someone was trying to kill him. The Dane suggested that we hear the Prophet out but that what the Prophet needed was treatment. It was our responsibility to make this clear to him. "You will remember," the Dane remarked, "what happened to your friend Celan." What happened to Paul Celan was that he became increasingly depressed and paranoid, to the point of fearing that his friends, wife, and child were conspiring against him. At the age of forty-nine, he was found dead, having drowned himself in the Seine.

The Prophet arrived. He came directly to the table with-

out ordering coffee from the woman at the counter. The Prophet rarely ate and never drank coffee.

As soon as he sat down, the Prophet's hand, which had been pulling at his ear, migrated to just above his polished head. There it circled for several seconds before landing.

"The bastard is after me," he announced.

The Prophet had many enemies, so it was not clear to whom he was referring.

"Grandpa!" he said. "He's been talking to Mike, and if Mike listens to his junk, I'm through."

The Dane and I did not know Grandpa, but we knew Mike. He managed the flea for the man who rented the garage and lots on the weekends. He collected rents, assigned stalls, and made certain that anyone who was unruly was turned out.

Because spaces were limited in the garage, plenty of dealers were ready to take them. But Mike was loyal to those vendors who had been coming to the market for years and with whom he had formed an affection. If these vendors were sick and absent for a length of time, he made certain that when they returned they got their old spaces. Mike was also someone who, at the risk of losing his job, helped vendors with their rents if they were having financial trouble by allowing them to go for months without paying.

He was also someone who did not tolerate those who belittled others because of their race or because they were poor or because their behavior was eccentric. Nor would he tolerate visitors to the flea acting condescendingly to the vendors or behaving impolitely in their negotiations or falsely accusing

the vendors of misrepresenting what they were selling. If there was a complaint about Mike, it was that he provided for the poorer, sicker vendors by demanding increased rents from the ones who were only slightly better off.

"You've seen him," the Prophet said, his eyes darting around the café and behind its counters to make certain Grandpa hadn't followed him. "He used to have a gallery in midtown, which he closed a couple years ago. But he couldn't stay away and started coming down here to buy. He sells to dealers uptown. He and I were close. Ten years ago, I went to his seventy-fifth birthday. Big and expensive. I got up and said nice things."

The Prophet took a long breath. His hand left his head and was now back in his lap, where it napped. With his other hand, the Prophet picked up a napkin and began to sniff it. Sniffing napkins and tablecloths was another habit of his.

As the Prophet's story proceeded, it became clear that Grandpa was a picker and, more specifically, a competitor. The crisis had occurred earlier that day, when the Prophet, while chatting with a vendor in the flea, spotted a portrait in her booth. The subject of the painting was an English soldier, dressed in a uniform from World War I. It was not the sort of painting that would command much money in the flea, and the vendor was not asking much for it. The Prophet, who was not interested in the portrait, knew who the painter was, and began to recite by memory the last four years of the painter's auction records. The vendor, who knew nothing about the painting, had priced it much below its value at auction.

At this point in the story, the Dane, who had been wait-

ing for a chance to raise the issue of the Prophet's mental health, was fully engaged. His coat was off, and he was jotting notes on the story with one of the many pencils he kept in his pocket.

What the Prophet did not know was that Grandpa, who collected nineteenth-century portraits, had also recognized the artist and had been back and forth with the vendor that very morning attempting to drive the price down. Just before the Prophet arrived, Grandpa, feigning offense at the price of the portrait (though knowing full well its market value), marched away, hoping to get the vendor to come down further. It is a common feint among pickers, and it might have worked had the Prophet not stepped into the vendor's booth.

When Grandpa heard the Prophet going through the artist's auction records, his thin and grizzled neck shot out from his shoulders—"three or four feet," according to the Prophet—and then years of invective, fermenting inside of him, gushed from his mouth. So unsettling was this, the story continued, that Mike had to escort him to the sidewalk outside the flea.

Before he calmed down, Grandpa swore that he would get the Prophet banned from the flea. Had Mike listened to him and forbidden the Prophet from entering the flea, the Prophet would have been bankrupt.

But Mike understood that pickers secretly despised each other, especially those who, like the Prophet, when not interested in a particular object but knowing it to be worth more than what a dealer was selling it for, disclosed the real value to the dealer. He also knew that of all the peculiarities that

had gathered inside the Prophet, guile was not among them. After listening to the Prophet and Grandpa, Mike concluded that the Prophet, having not seen Grandpa in the neighboring booth, had acted innocently. Mike also felt sympathy for the Prophet as someone the rest of the world had difficulty understanding but who seemed to fit in at the flea.

The Prophet dismissed the whole episode as "Grandpa having a hypomanic episode" and swore that he would not attend any more birthday parties. The truth may have been simpler than Grandpa being unstable: Grandpa, envious of the Prophet's brilliance at picking, was trying to get his competition removed from the flea.

While I had the Prophet and the Dane with me, I asked them about the Cowboy. They would know him or, at least, of him. The Prophet spoke first.

"That man. Very dangerous. A murderer."

We were certainly speaking of different men.

"The old man with the cowboy hat and a limp?" I asked.

"Yes. The Cowboy."

The Dane got up from his chair. He had an appointment in the garage and had to leave. But when I asked him whether the Prophet was right about the Cowboy, he nodded.

"He's also known as Chief."

"Why?"

"They say he lives with the Indians."

With that, the Dane departed.

"The Dane thinks I'm going to kill myself, doesn't he?" the Prophet questioned as soon as the Dane was out the door.

Yes, but how had he known that?

"When the Dane is worried about something, he plays with his pencils. As soon as I sat down, he began rolling one in his fingers. At a certain point, he snapped the eraser off the top. The eraser is a symbol of death, and the death of an eraser even more so. Tell him not to worry about me killing myself. I am, after all, 'the Prophet,' and I don't see it."

He laughed.

. . . .

A WEEK LATER, I met the Cowboy for fried chicken at a restaurant on the corner of Broadway and Twenty-Fifth Street. The Cowboy explained that he had been living in Colorado for decades. Upon returning to New York, he was drawn to the flea, and he lived and painted in a small apartment nearby. When he needed money, he would buy and sell metal beads—especially those made in France in the late nineteenth century. The beads were intricately carved and had been used for jewelry and decorative detailing on dresses, coats, and purses. There was a very strong market for such beads in Europe; but in the U.S. they were overlooked, even by the most sophisticated pickers. A single bead, he claimed, could be worth thousands of dollars.

The Cowboy offered to show me his collection of beads as well as his recent artwork.

He preferred bringing whatever he wanted to show me to the flea. We arranged to meet at the flea the coming weekend.

As rarefied as the Cowboy's collection was, he was not the only one in the flea who collected beads. There was

a middle-aged woman who visited the flea regularly and whom I had come to know because we were often visiting the same vendors. I never saw her purchase anything. One day, standing next to her at a booth in the open lot, I asked her what sort of objects she was looking for in the flea.

She explained that during World War I, a number of men from western Asia were held in English prison camps. While they were in prison, they would take bottles and other objects given to them by the guards and cover them with beads. The beads were crocheted into patterns that the guards found attractive, and the guards, in turn, would send them home to their families as gifts. The prisoners who made the objects were rewarded with money or privileges.

During her explanation of the long history of beading objects, she pulled her purse off her shoulder and began digging through it.

"I'm leaving for my house in Greenwich and decided to bring up my favorite bottle. I've just completed a renovation and wanted something nice for the shelves."

She removed a bottle from her purse and placed it on the table next to where we were standing. We admired the bottle: it was crocheted in horizontal strips of black, dark green, and navy beads. In the center was a coat of arms comprised of red and golden beads.

"This was made for one of the great families of Turkey," she said. "It took me time to find exactly which family but it has now been verified by one of the family members. He offered to buy it for whatever I wanted but I could not bring myself to sell it. I wanted to live with it for a while. That was ten years ago."

I picked up the bottle. It had a stopper that was also beaded.

"Very rare to find the stopper," the woman pointed out. "They are almost always lost or broken. Dishonest sellers will create a new stopper and tell you it's old. It's one of my best pieces."

Because I knew the woman to be not just a collector but a picker and, more significantly, a picker who—like the Cowboy—was willing to sell in the flea, I was able to translate the true meaning of our conversation. Only a handful of pickers would risk attempting to sell in the flea because, in the eyes of the owner of the flea, a picker who sold in the flea ceased to be a picker and became a vendor, and vendors were expected to pay a fee to the owner. Pickers who sold in the flea were at risk of being permanently expelled. For this reason, their conversations about selling were elaborately sheathed, not unlike the bottle the woman had brought in her purse.

The mention of the house in Greenwich was meant to signal that she was an affluent collector and therefore did not need to sell in the flea or anywhere else. Whether she actually had a house in Connecticut was irrelevant. So too was whether there was someone from a grand family of Turkey or anyone else who was willing to pay a significant price for the bottle. The suggestion of it would make me feel good about buying it for a price that might otherwise seem extravagant for a beaded bottle.

Further, the claim that she was hurrying off to the country let me know that if I did not make an offer on the bottle

immediately (that is, before I could check out the prices of such bottles), I would miss my opportunity.

Approximately 120,000 years before my conversation that afternoon in the parking lot, an early human transported shells that had been made into beads from the coastal waters of Algeria to an area of the interior now known as Oued Djebbana. An evolutionary biologist has suggested that the human's purpose in bringing the beads to Oued Djebbana was to trade the beads with a tribe that did not have access to the coast and thus to beads. The scholar goes on to suggest that such an exchange could not have occurred without a rudimentary language and that the desire to trade beads was the impetus for the invention of language.

Though honored to be part of the ancient tradition of bead trading, I turned down the offer of the bottle by telling the woman I had no money on me and that if she wanted me to buy the bottle she would have to wait until the flea reopened in a week. The purpose of this was to give me time to do my research on beaded bottles.

She turned down my offer but was not in the least upset. In Greenwich she would no doubt encounter another tribe with which to trade her beads.

A week after our lunch, the Cowboy and I met in the lower level of the garage. Unlike the woman, whose beads decorated a bottle, the Cowboy's beads were loose in his pocket. Just a couple beads, but each with a history similar to what I would learn was the Cowboy's tale: an initial prominence (they were made for a notable person or given as a gift to a king or queen), spent a long period in which they were

forgotten, and then were rediscovered by a new and appreciative audience. None of the Cowboy's beads were for sale.

My conversation with the Cowboy ended when Paul the haberdasher arrived. He was carrying two suits from a tailor in Naples. The tailor had made the suits by hand in the 1950s and, according to Paul, they were never worn. While examining the details of the suits—stitching, fabric, lining, buttons—I asked the haberdasher why he limited his sales in the flea market to clothing. Why not American antique furniture, for example? He often spoke in a way that showed considerable knowledge of the subject.

"Empire chairs, chandeliers, chaise lounges? Are you kidding?" he spat. "Look at these poor bastards around here. They spend all day on Friday packing their stuff. They wake up at three in the morning on Saturday to drive for hours to get to the flea by six o'clock so they can be set up for the pickers at seven and then the public. They have to park blocks from the flea, unload their boxes and furniture onto carts, push the carts through the streets to the flea, then unload the carts into their stalls. It's ugly, filthy, and backbreaking."

Paul, with climbing contempt, continued detailing the hardships and indignities that the other vendors suffered and that they were not smart enough, unlike himself, to avoid. But his contempt was false because Paul only knew the details of what it took to get antiques and furniture and chandeliers and couches into the flea because—and Paul would never admit this—he would make a point of always arriving early to help the other vendors unload their vans and push their carts and empty those carts at their stalls. And if needed, he would

assist the other vendors in setting up their displays on their tables.

· · · ·

THERE WAS SOMETHING ELSE I needed to discuss with the Prophet.

As I'd gotten to know him, I'd been warned by one of the vendors at the flea: the Prophet was a hoarder. Despite the fact that the Prophet's apartment was around the corner from the flea, he had never invited me over.

I was deeply curious, but the accusation had little impact on my view of the Prophet, for what was a collector but a hoarder with a storage unit? Still, I wanted to know.

"My dear Prophet," I began, "when I was a child in Nebraska, someone lived with us, and after she died, we found that she had filled the floor, closets, and shelves of her room with newspapers, specifically those that had articles about the British royal family. There was no space to walk. But as far as I could tell, and accepting that I was only a child, there was nothing obviously wrong with her. She raised me and had the presence of mind to educate me, take me on trips to meet her friends, that sort of thing."

"You are aware," the Prophet interjected, more seriously than I'd expected, "that the most recent *Diagnostic and Statistical Manual of Mental Disorders* includes hoarding as a distinct category of mental illness characterized by—and here I am quoting from the manual—'the failure to discard possessions regardless of the value others may attribute to these possessions.'"

"Which," I pointed out, with my dung sculptures in mind, "probably includes the two of us. I have not been to your apartment, but if it is anything like mine, you are a hoarder, at least according to the *DSM*."

The Prophet sat silently. When he finally spoke, he was barely audible.

"This condition of which you speak is associated with preexisting trauma and a propensity to depression. The hoarder is ashamed of his accumulation and attempts to keep it secret; but the collector seeks to display the collection and has pride in it. The hoarder will never invite you over." This was the closest he would come to answering my question.

The French sociologist Jean Baudrillard described collecting as rooted in an attempt to evade mortality, closely related to the fear of castration. It is not by chance, Baudrillard observed, that collecting is chiefly the habit of men just prior to puberty and men, again, as they become middle-aged. He also stated that collectors were people who felt alienated from society.

Some scientists have attributed hoarding to lesions in the brain, while others believe hoarding is genetic and consequently passed down in families. A problem with these suppositions is that they fail to account for the fact that historians have found little evidence of hoarding prior to the last century. Even the word "hoarding" did not acquire its current usage until recently. Before, it was used to describe a person (especially one of wealth) who refused to spend their money.

Though I did not wish to admit it, this subject—the definition of collecting, the difference between collecting and

hoarding, and the roots of each—was something about which I had more than a slight curiosity.

Many in the flea called me a collector. Those outside the flea, a hoarder. According to the Prophet, I was a hoarder. But neither term—collector nor hoarder—seemed appropriate. I was not someone who systematically and proudly assembled objects of value, nor was I hiding in a vault of newspapers and cans of cat food. Nor did either term fairly define the people I'd encountered at the flea. The function of the two terms, it appeared to me, was not descriptive but social; that is, to warn those in society against straying too far into the ambiguity of objects and the relationships they were capable of establishing with humans. The message was that if you are not in control of objects, categorizing them according to a strict logic of society's making, setting them up in cases and constantly monitoring their status (that is, if you stray from your job as warden over these prisoners), then you are a hoarder and the very objects you invite into your home will destroy you.

7

THE ANTIQUE CAFÉ, WHICH WAS DIRECTLY ACROSS from the Twenty-Fifth Street entrance to the garage, had been opened by an Armenian named Danny, who, before arriving in New York, lived in Rajasthan. Danny was in his forties. Because he was short and rotund, with no hair on his head but a dense carpet of it covering the rest of his face, he had the appearance of a well-scrubbed mushroom. When he moved to New York, he knew that he had enough money to live for a year while looking for the right job.

He quickly found his way to the flea and from there to spending ever-increasing amounts of his money. One day, to his surprise, he discovered that all he had saved in his years abroad was gone. But Danny was clever, and he noticed that there was no café or diner around the flea that was open at five in the morning, which was when vendors and pickers arrived. Danny had in mind the cafés and bars of the flea market in Paris and the small coffee shops and hookah bars in the souks of the Middle East. Consequently, Danny, who had never owned a restaurant, opened the Antique Café, and it soon became a success. There were any number of people who,

addicted to the flea, had spent most of their money there and ended up working in nearby restaurants, salons, and shops.

The Antique Café was not only unusual for the early hour of its opening but also for the quality of its offerings. Danny, drawing on the time he'd spent in different parts of the world, prepared an assortment of unusual salads and meats. The Antique Café was immediately full, and Danny was the ideal host: discreet as to who was at the café and what they were discussing.

Celebrities such as Catherine Deneuve, Bobby Short, Andy Warhol, and Barbra Streisand, and people connected to the design and fashion industries, came to the flea. The Fashion Institute of Technology was just west of the flea, and its mix of aspiring designers, models, and students would often show up at the flea dressed in flamboyant outfits, hair-styles, and makeup.

For all of these people, and for me, the Antique Café was the place to gather after a couple hours at the flea. Though the café had only six tables, people found a way of crowd-ing in, and Danny made certain that everyone was served promptly and that no one was uncomfortable. The fact that everyone was sharing tables meant unexpected friendships. That was how I came to know the Dane and the Prophet.

Early one Sunday morning, I was sitting in the café when a man shouted out, "Danny, what is this?"

The man held a slice of bread and jam above his head.

"Rose hips?" the man speculated, with no help from Danny, who was retrieving something from the refrigerator. "But possibly not. You might also use rosewater with some-

thing else added in. I can't say. But it does taste a little like that drink. What's it called? Cockta. Is that it? Cockta. I can't be sure."

At this point, the man with the bread and jam spotted me, left his seat, and walked over. The bread and jam came with him.

"Excuse me, I've seen you in the flea but didn't want to bother you. That may not be exactly right. I may have wanted to bother you, but was waiting for the Prophet to introduce us. But maybe that's not so either. If the Prophet introduced us, then I would probably not have told you what I wanted to tell you because the Prophet has already heard the story and I would not want to bore him—even though he said that if you and I talked and I told the story, he would not be bored. Do you think that the Prophet is telling the truth or just being polite? I can't tell. As you can see, it's confusing. Or is it not confusing? I would be interested in your opinion. I am certain of that. So let me know your opinion and that will help me."

The Prophet had told me about this man—Harold was his name.

I invited Harold to join me, and he thanked me and sat down. But he seemed surprised. He gave the impression of a man who expected people to say no.

Harold had grown up in a family of artists, and when he was not playing ball or doing his homework, he was looking at art and reading about art. When he married, he chose a woman who designed jewelry.

Harold was not an artist—he worked as the assistant office

manager at a brokerage firm—but he studied art and spent his weekends going to museums and galleries. When he returned home from a museum, he reported to his wife on what he had seen. His wife would set aside what she was working on to listen to him. She was always impressed with his observations. Harold and his wife lived in this happy way for many years.

Sometimes Harold would go to galleries with his younger brother, who was a photographer. Harold discussed art with his brother, and what Harold said shaped how his brother thought about his own work.

More often than not, Harold and his brother dined together at Harold's apartment, and if his brother wanted to invite friends, many of whom were also artists, Harold and his wife could always find room for more people at the table. As his brother became famous for his photographs, the dinners grew larger, expanding to include writers, critics, and curators.

Harold greatly enjoyed these dinners because he was able to talk to smart people about what he and they wanted to talk about—art. It was not surprising, then, that as more people got to meet and listen to Harold, they told him that he should be a curator or teaching at a university or work- ing at a gallery. Few of them thought to ask Harold what he thought of the job he was doing as an assistant office manager.

While Harold's job did not earn him much money, he enjoyed his coworkers. They would have lunch together and celebrate their birthdays with wine and a cake. And if Har- old got sick or wanted to take a day off to go to a museum

out of town, the others covered for him and the owners of the company never complained. They too liked Harold.

Harold's job also allowed him to save money, and when, in the flea market, he saw something he liked, he could afford to buy it. Whatever he bought, he would hang on the walls of the loft where he lived. With few exceptions, his wife was pleased with what Harold brought home, and not infrequently Harold would come back with something that would turn out to be very important. Harold would learn about this from the research he did or from discussing the object with the Prophet.

As Harold's collection grew more valuable, Harold's brother said, "Harold, you should just buy and sell art from the flea market. With what you know and all the things out there every weekend, you could support yourself."

Taken by this idea, Harold started buying and selling in the flea. At first, lacking confidence in his new role, he spent only modest amounts. And at the beginning it was not easy: he had to find the dealers or collectors who would buy the things he bought. When he went a weekend or two without buying or selling a painting, he would worry; if he bought something he thought was important and it turned out not to be, he would despair. Sometimes he thought the objects in the flea were playing a joke on him or even warning him.

But gradually he came to know the vendors likely to have the better paintings and sculptures, and he gained the trust of collectors. His buying and selling became more efficient. More profitable.

Then there was the day that Harold's brother didn't come to dinner. Harold's wife said that he had called: he had been working on a show and was exhausted. But the exhaustion was not just because of the show.

Harold and his wife attended the show, and it was a wonderful evening. At the dinner afterward, after many people had toasted Harold's brother, Harold's brother stood and gave a short speech, thanking everyone and especially Harold. He predicted: "One day, Harold will find something no one else but he would notice, something priceless, and people will talk about him for years to come."

While Harold's brother was creating photographs for his show, he was dying of AIDS. While caring for his brother, Harold stopped visiting friends, stopped inviting artists over for dinner, and even stopped going to museums and galleries. But he continued to visit the flea market to wander around the garage and especially the open lots, where the sun dried his tears.

It was at the flea, in one of the open lots, months after his brother's death, that something stopped him.

A portrait of a dancer waiting just offstage, a cheap reproduction of a Degas drawing. The portrait was in an old and inexpensive frame. A plate of cigarette-stained glass covered the portrait.

Degas was well known for his portraits of dancers, of course. They had been reproduced in so many forms that they frequently were seen in flea markets and thrift shops. They were always inexpensive and would never cause a ·

picker to stop. But there was something that day that caused Harold to stop. Something small. Very small. A smudge.

That smudge told Harold that this was not a reproduction, but something else. A drawing. The artist's hand or sleeve had passed over the work, causing the imperfection. Harold heard the echo of his brother's toast: that Harold would find something everyone would talk about for years to come. There was also the Prophet, who happened to be in the flea at the time of Harold's discovery and said he was certain it was in fact a Degas original.

Harold purchased the drawing. The vendor he bought it from was himself an artist. He was not represented by a gallery but showed his work at an arts club on lower Fifth Avenue, just above Washington Square. Harold had attended one of his shows. The vendor, Harold thought, had only himself to blame for mistaking the drawing for a reproduction.

When Harold returned home, he leaned the drawing against a vase he'd inherited from his mother, which held his brother's ashes. He did not tell his wife about the drawing, for he wanted to see how long it would take her to notice it.

The answer was not long. She was startled by it, and when he explained to her what it was and how he had heard the voice of his brother, she began to weep.

The following Tuesday, Harold wrapped up the drawing, put it in a stiff plastic container, and took a cab to a famous auction house. After waiting an hour, he was shown into a small room, where a well-dressed man in his late thirties and a woman in her mid-twenties greeted him. The man

wore a suit that was snug. Harold unwrapped the drawing and placed it on a table. He was excited to see their reactions.

There was no excitement in their faces, and the first thing they said to Harold was that they would need to have someone else look at it. They wanted to make sure it was a drawing, though Harold thought it should be obvious to them. The smudge, after all.

A phone call was made, and an attendant entered the room and removed the drawing.

While they all waited for the analysis to be completed, the man asked Harold where he had obtained the drawing. Harold told him exactly what had happened. Harold did not want to appear to brag, but he felt proud that he had spotted the drawing when everyone else in the flea market thought it was a print. As Harold went through the story, the young woman took notes. The man asked more questions. Harold sensed that he was smug.

The drawing arrived back in the room, delivered by a man wearing white gloves. The man wearing white gloves whispered to the fellow in the suit. The two excused themselves from the room.

The smug man in the snug suit returned. He addressed Harold.

"While you are right about this being a drawing and the paper is consistent with that used by Degas, it is not, in our opinion, a work by Degas. In our opinion—and we can certainly have others look at it—this is the work of someone else. I don't want to say a forgery; it could just be a student copying Degas or an amateur attempting to imitate the

painter. It is quite common for copies to be produced in this way. In art schools, for example, there is a tradition of asking students to develop their technique by going to museums and having them copy . . ."

Harold had stopped listening. He did not know what to say. He himself had read books and articles on Degas, seen exhibitions of his work, studied the catalogues to those shows. He had no doubt that the artist had created the work.

Disappointed, Harold returned home. He did not tell his wife what had happened. It was the first time something so important had happened that he did not share with his wife. This made him angry, and sad. He thought again about telling her when they were lying in bed that night, but she fell asleep before he could speak.

The next day, the woman from the auction house called to say that if Harold wanted another opinion on the work, he might contact a certain gallery, which was known for handling Degas's work.

Harold called the gallery as soon as it opened.

The gallery owner was an older man with round glasses and a lovely manner. His office was a fine, large office in midtown, on the ground floor of a town house. Even nicer than the offices at the auction house. This man, Harold felt certain, would recognize the work immediately. Harold also guessed that this man, impressed with what Harold knew about Degas and about art generally, would suggest some sort of collaboration with Harold on other works he found in the flea. So Harold told the man how he had spent years in the flea market and had come to know the dealers—the ones

who were likely to have good paintings and sculptures and the ones he avoided; he told the dealer about the research he had done, the many volumes of art books on his shelves, and about the Prophet, Frank, and others he relied upon for a second opinion.

Then Harold got to the Degas. As Harold described to the man how and where the drawing had been discovered and why he had no doubt (despite what the people at the auction house had said) that it was done by Degas, Harold saw in the man's expression that he didn't care whether it was drawn by the hand of Degas. At that moment Harold understood that what Harold had prided himself on—his ability to recognize works of art in the flea market, the research he devoted himself to at home and the library, his relationship with people in the flea market, and the flea market itself— were all laughable to the owner of the gallery and that the only thing this man cared about was whether the drawing had come from a place (a well-known gallery, a wealthy collector, a prestigious auction house) that would be meaningful to one of his clients. The list of those places did not include the flea.

Harold waited for the man's excuse, and it came quickly and politely, for the gallery owner was not a bad man. Without ever commenting on the authenticity of the drawing, he told Harold that he didn't think he had a buyer for the drawing and that he would keep Harold in mind if things changed.

The gallery owner, without revealing it to Harold, had already moved Harold and his wife and the drawing and the

flea into an amusing story he would share with his young interns when they had lunch the next day.

As the gallery owner walked Harold to the front door of the gallery, he told Harold that there was an exhibition of late nineteenth and early twentieth century drawings going up in the gallery at the end of the month. Harold should feel free to come by. Hearing this, Harold, with the Degas under his arm, whispered into the ear of the gallery owner.

"Fuck you."

"What?"

"I said you're a big fuck."

But this time when Harold said it, he did so in a way that smeared it across every white wall and blond-wood chair and black dress and suit in the gallery.

Harold could not remember the last time he had used language like that. Maybe when he was a teenager. Maybe when his brother died.

It was, after all, how he felt, and it was how he responded again and again in the months that followed when others told him the same thing: that the pastel was not what he thought. The fact that each person gave him a different reason for rejecting the Degas made him even more convinced that they were rejecting it for only one reason—it had no history other than that he'd bought it in the flea.

As to the auction houses, he came to believe that they were only experts in knowing where private collections were located. The man in the suit at the auction house went to an elite school, stayed in touch with his friends there, and when shaking the hands of every elderly man and woman

who had a serious collection he would slide his index finger up their sleeve to check for the hopeful sign of a sickly pulse.

Harold went to France to have experts there authenticate the drawing. But they had already heard the story of Harold, and despite all the money Harold had spent on testing the paper and the pastels and the thirty pages he wrote on why it was authentic, no one would respond to him.

Determined to prove himself, Harold spent more and more on objects at the flea that he was convinced were the work of famous artists. He became bolder in his judgments. People became distrustful, and soon his customers stopped responding to his phone calls. With his money invested in objects he could not sell, he and his wife were forced to move into a series of smaller apartments, while his paranoia and depression grew. To whomever would listen, he continued to repeat his story.

Harold had fulfilled his brother's prophecy: he had found a work of incredible value, something no one else but he could have found, and people will tell his story for years to come.

8

IT WAS AROUND THIS TIME THAT THE LONGTIME
owner of the Chelsea Hotel sold it, and the new owner began
a multiyear renovation. My wife and I had to move out until
the renovation was finished. Concerned about the accumula-
tion in my apartment and believing that my proximity to the
flea was part of the problem, I chose an apartment uptown. It
had floor-to-ceiling windows, little wall space, and no shelves.

I was in the process of moving when I stopped off to have
lunch with the Cowboy. Dressed in his usual black jeans,
shirt, and cowboy hat, he was sitting at a counter facing the
window. There were others around him at the counter but
he spoke to no one.

Taking the seat next to the Cowboy, with both of us star-
ing out the window, I apologized for being late, explaining
that I'd just dropped off my clothing at my new apartment
on Sixty-Fourth Street.

"West or East?" he asked.

"West."

"Near the River?'

"A block off it."

"South or north side?"

These questions, to be expected from anyone else, were surprising from the Cowboy. Since I had known the Cowboy, he had never asked me about my life, certainly not about the block where I lived.

"North."

"I grew up there," he said.

"I would not have guessed it from your accent," I replied. Or his clothes. Or manner.

"I was born in Virginia. My parents brought me here when I was ten. The neighborhood was called San Juan Hill, and there were jazz musicians all over. I started playing the vibraphone. One night, a guy in the neighborhood calls me and says: We're going down to the Five Spot to hear Monk. I got to know Monk and then Miles, who also lived in the neighborhood. Around this time, when I was still in my teens, I started shooting heroin."

The Cowboy took a break to finish his coffee. He drank slowly. Not until he finished did he continue.

"I was arrested for drugs and by then was old enough to be put in prison. A therapist in the prison thought that making art would help me break my habit, so I started painting. It was the early sixties, I was in prison, and I was becoming political. When I got out, a couple friends and I formed the 'Black Mask.' We were artists and anarchists.

"We broke into the Pentagon, smashed up galleries, smeared shit on the walls of museums. We filled the fountain at Lincoln Center with garbage."

This was coming from a man who barely cleared a hun-

dred pounds, had trouble walking, and spent most of his time looking for beads.

He began again.

"When we heard that there was an Irish gang beating up radicals in Boston, we went up there to protect them. Someone got killed, and the police arrested me and charged me with murder. They wanted me to make a deal and knew that because I'd already been in prison, I would want to make a deal, but I told them to go to hell. I hated prosecutors and was convinced that they would never try me. But they did. They tried me for murder.

"The trial took a couple days. The jury let me off, and I came back to New York. That's when my friend and I started publishing the *Black Mask*," a magazine.

The Cowboy pulled some yellowed drawings out of his bag.

"I did the illustrations and some of the writing. I enjoyed it but it was a lot of work. One day I met a girl. She was homeless, dragging a suitcase behind her. She was pretty and smart and I invited her to stay with me, and she moved in.

"She and I became best friends. Soon she felt comfortable enough with me to show me her writings. That is what she had in her suitcase.

"Well, those writings were incredible, and I asked her if she would write for the *Black Mask*. She agreed. We would sit in our apartment, while she was writing and I was doing illustrations.

"One day she says that the name of the magazine stinks. And I say, 'Well, do you have a better one?' and she responds,

'*Up Against the Wall Motherfucker*.' From then on we called ourselves and the magazine '*Up Against the Wall Motherfucker*.'"

Condolence took the place of kindness on his face.

"As I told you, we hated the art establishment. We were trying to free art from money. That was the point of everything we did.

"One day the girl and I are having lunch, when she says to me, 'Cowboy, of all the artists we know, who is the most hateful?' and I said, without thinking, 'Andy Warhol.' She nods and then says, 'Cowboy, what if I killed Andy Warhol?' and I said that she would be jailed and probably executed.

"When we finished lunch, she got up and left the apartment. As she was leaving, I asked her if she would pick up something from the bodega on the corner. That was the last time we spoke."

"Why?"

"Instead of going to the bodega, she bought a gun, and with the gun, she shot Warhol. The next thing I know, the newspapers are calling and asking me to explain what happened, and I said that the shooting made a lot of sense to me.

"So when I made that comment to the papers and with that murder charge in Boston, the police were convinced I'd given the girl the gun and told her to kill Warhol.

"Then I run into a friend on the street. He says that the FBI are looking for me and that when they find me they're going to kill me. I did not go back to my apartment. Instead, I got in my car, and I didn't stop driving until I was in the mountains of Colorado. When I'd driven so far into the

mountains that there were no more roads, I junked the car, bought a horse, and rode until I came to an Indian tribe. And that's where I stayed."

The Cowboy stayed in the mountains for decades. He became involved in tribal practices, including the tribe's "vision quest," a ritual in which a member of the tribe, having isolated himself for an extended period, comes into contact with a parallel world that the participant realizes is omnipresent but also inaccessible. Acceptance and quiet in the face of the unknown delivers the participant to a state of deep wonder, according to the Cowboy.

When the Cowboy left the tribe, he took up homesteading, feeding himself from what he grew on his land. And when he needed money, he worked as a lumberjack. It was while doing that job that he cleaved through his leg with a power saw. The damage to his muscles and bone meant that he would limp for the rest of his life.

When he finally returned to the East Coast, the Cowboy worried that the police were still after him. But he felt safe in the flea. When he was not in the flea, he painted. The new paintings were ink on paper—broken circles of muted colors placed on a field of gray. He described the paintings as "cosmic microscopes."

The Cowboy's view of the world had a good deal in common with something that had interested me for years. Known as negative theology and dating back to Plato but found as well in Christian and Jewish theology, it is based on the idea that God, owing to its radical foreignness, is unknowable. One can discuss what God isn't but never what God is. To

discuss positive attributes of God results in facile analogies to humans and these interfere with our appreciation of the unfathomable nature of God. The God one knows is no God. It is a philosophy that influenced Emmanuel Levinas's ideas.

I spent most of the afternoon with the Cowboy, first at the restaurant and later at his apartment, where he showed me the "cosmic microscopes." As I left the Cowboy's studio, my mind was filled with thoughts I had left dormant for too long. I was determined to set up a desk in my new apartment and devote myself to the work I'd abandoned years before.

· · · ·

I WAS STILL WRESTLING with what was true in the Cowboy's story when one very cold day I bumped into his fellow picker the Dane.

I had heard from others in the flea that the Dane had been writing and rewriting a dissertation on Henri Poincaré, the mathematician and physicist, for over a decade. The Dane's inability to complete the paper was the reason why he had never finished graduate school, why he was unable to get a teaching position, and why, instead, he was supporting himself by picking at the flea.

"I have been working on my dissertation for years," he told me. "It is incomplete, and it is mostly wrong, but I want you to see it." We arranged to meet for lunch later that week at a restaurant with a long wooden table. The restaurant had been selected by the Dane for the table.

When I got there, I found the Dane at the table with a large notebook in front of him. Next to the notebook were

a few books and a pencil, and next to the pencil, a pencil sharpener. Beside the sharpener were four erasers of different shapes and sizes.

The Dane believed that Poincaré, though widely respected as a mathematician, was more important for his work on psychology. The Dane opened a book by Poincaré and began to read.

The subliminal self is in no way inferior to the conscious self; it is not purely automatic; it is capable of discernment; it has tact, delicacy; it knows how to choose, to divine. What do I say? It knows better how to divine than the conscious self, since it succeeds where that has failed.

The Dane then turned to the flea and our mutual friend the Prophet.

"I buy on my gut, listening to signals from my unconscious; the Prophet relies on auction records to tell him if something is valuable. So instead of relying on his unconscious, he's surrounded in his little apartment with objects, paintings, and sculpture that are only meaningful to other people. He has suppressed the idea that the objects in the flea speak directly to his unconscious, and to ignore that inner conversation is damaging. And that is why the Prophet is disturbed."

The Dane was not like the Diops: he did not believe that objects were instilled with a spirit that communicated with members of the tribe. What he was suggesting was that objects were wholly and undeniably material and because of

that quality they had a distinct and significant psychological impact on humans. That impact should not be ignored, and when favorable should be acted upon immediately by entering into a relationship with the object.

There was something else he wanted to tell me.

"I understand," he said, "that you are spending a lot of time and money at the flea. My guess is that you may believe that you are diseased and will end up as a headline in the newspapers—'Promising Chap Found Suffocated by His Own Rubbish,' or something like that."

He was not wrong.

"So I thought I would tell you something that I saw many years ago, something that might help."

I relaxed into my chair.

"I was in the open lot early one morning," he began. "It was before the sun came up, so it was very dark in the lot and guys are sweeping up the bottles and condoms from the night before. A dealer I know, who usually sells rugs, pulls up in his van. When he opens his trunk, we see that it's full of boxes. I was about twenty feet away and toward the back of the crowd waiting for this guy.

"The guy starts throwing the boxes into the lot from his trunk. A blade of light from the rising sun strikes the lot, igniting the gilded spine of a book in one of the boxes. This causes a golden funnel to rise from the box. I don't know what the book is but I know I want it.

"I push my way through the other pickers, reach inside the box, pull out the book, and drop it in my bag. I don't

even look to see what the book is or what condition it's in. From the time I saw the book to the time it went into my bag was maybe twenty seconds. I ask the dealer the price, he tells me, and I pay him. No bargaining."

The Dane leaned forward in his chair.

"That same day I took the book to a dealer on Madison Avenue, the one next to the cigar store, and he gives me a thousand for it. No questions asked."

The Dane laughed.

"Imagine pulling something like that out of a parking lot at five-thirty in the morning and selling it for a thousand dollars a couple hours later."

When I thanked him for the story, he stared back at me.

"That's not the story," he said, disappointed.

Returning his coffee to the table, the Dane started again.

"A year ago, I met a Russian in the garage. Perhaps you've seen him—old, short, wears a worker's cap. He has a pointed beard."

I knew the man. He was a friend of Frank's. The old man could stand for hours with one painting. Pulling the painting to within an inch of his eyes, he would inspect it, turn it over, and begin again on the back of the canvas and stretcher.

The Dane continued.

"I was at Frank's looking at a chessboard, when the old man, who had never spoken to me, asks me if I play chess. I say yes, and a couple weeks later, he calls and invites me to his apartment in the East Village. He lived on the same street

as Allen Ginsberg. The man's wife died six months before, they had no children, so he spent his time playing chess and wandering the flea, though mostly at Frank's.

"His father was one of the great restorers in Russia, and from watching his father work on paintings, he picked up an eye for what's real and what isn't. When his father died, he took over his father's studio. When the man was in his seventies, things became uncomfortable for him in Russia, probably because he was Jewish, and he came here. Frank likes having the old man around, and the old man respects Frank. Frank once told me that he can see in the Russian's eyes whether the Russian thinks something is genuine or not, and Frank claims that the Russian's eyes reveal it to Frank before they reveal it to the Russian."

This would explain the manner in which the Russian inspected paintings. Paintings disintegrate in specific ways—paints fade; varnishes change color; bubbles may form if an artist is impatient and does not wait long enough for a painting to dry before applying a new layer, and sections of the surface thereby become unstable.

There is also "craquelure." Paints and the materials added to paints (such as solvents, which are used to thin paint) evaporate, and this causes the surface of a painting to shrink and crack. Paintings will have distinct patterns of cracking. Paintings from the Italian Renaissance will have crack patterns distinct from seventeenth-century Dutch or eighteenth-century French canvases. Knowing this helps experts spot forgeries.

"The Russian used to collect, but it's been years," observed the Dane. "When he collected it was old chessboards, back-

gammon boards, and books on chess and backgammon. In the last few years, he's sold almost everything to pay for his wife's medicines.

"The only things he didn't sell were a chessboard, a couple pieces of furniture, and a photo of his wife. The photo is small but in a gold frame, maybe Austrian. As soon as I arrived, we sat down to play. From the start, I knew that he was a strong player. Then he did something which made me think that he was a brilliant player—but a brilliant player who, seeing that his victory was close, purposely prolonged the game.

"After my next move, he puts his hands on the chessboard and pushes it toward me.

" 'Take this,' he said.

" 'Why?' I asked.

" 'I want the book.'

" 'What book?'

" 'The book in the lot. The one with the gold lettering.'

"Well, he happened to be in the lot that morning. He was even farther away from the box than I was, which is why I got it and he didn't.

"I told him that I'd sold the book and that I couldn't remember its name. It had been a while. But he tells me it was an early edition of *The Monk*. So I said to him, 'If you know what it is, why don't you buy a copy?' I offered to help him find one.

"He then tells me that he doesn't want a copy; he wants that very book from the flea. For years, I thought about why he wanted that exact book. Then one day, after a lover

of mine died, I knew the answer: there is a point in chess, the zugzwang, when you have to move but any move you make will bring you closer to defeat. With his wife gone, he felt that way. Then one morning he sees a light from a book, and he knows his way around defeat. Suddenly he feels happy again."

I appreciated what the Dane was up to: he understood my obsession with collecting and the problems such an obsession inflicts. But he also understood that there was something in the flea other than objects and collecting—a salvation harbored in the chaos.

After an hour with the Dane and his insights, I headed out into the cold and walked directly to Morris's warehouse. I went to the basement and dug through the accumulation to revisit the portrait of Frances, for though the painting was undeniably the work of an amateur there were aspects of it that had settled in my unconscious mind.

Pulling it from the paintings that were around and on top of it, I set it on a couch that was upside down on the floor.

What I noted first was that though the top of the painting—the face and hair—was in three dimensions, consistent with conventional portraiture, the painting became increasingly flat as it moved from the neck into the blouse. Where the woman's arms crossed her body at the bottom of the blouse and where the book sat in her lap, there was no depth at all. This suggested a level of sophistication or, at least, a familiarity with the shift from three-dimensionality to flatness that occurred in twentieth-century art. This

shift was intended to move attention from what was being depicted in the painting to the nature and act of painting, that is, the application of paint to a flat surface.

The light in the painting also stood out. A traditional portrait would have had the light spread outward from a distinct source—window, lamp, candle—and it would flow across the figure and other objects in the paintings as it would naturally. The painting of Frances departed from that approach. There was light in the painting but patches of it scattered in different parts of the portrait, indicating that the light was under the control of the painter, not nature, and was to be used at the artist's discretion. A sharp patch of light just under one eye, for example, deftly brought attention to the eye, preventing it from sinking into the back of the painting.

There was also the mood. Joyous splashes and strokes of red were scattered almost randomly through the hair, face, and blouse of the woman. These were in contrast to the focused concern in the woman's eyes, as supported by the darkened yellows of the background, deep blues of the blouse, and very dark hair. This suggested that though the subject of the portrait may have been gazing at someone else, presumably the artist, with concern, the artist may not have shared that worry when staring back at the woman. The degree to which the artist was using color to reflect his own mood also seemed to me typical of the shift to the modern and away from the traditional dedication to an illusionistic depiction of the subject of a painting.

What also indicated the sophistication of the artist was that the individual parts of the painting were fused into a

coherent assemblage, which may be why it was so easily recalled to my mind after I had seen it just once, and briefly, before. This is not so easily achieved, and there is a long history of thinking regarding the unity of a work of art. In the painting of this woman, the cactus, book, hair, and face of the painting were set on a single diagonal running from the bottom right-hand corner to the top left-hand corner of the painting. The strong diagonal was a compositional technique associated with Titian.

I was enraptured and could resist the painting no longer. I carried it upstairs and asked Yitzhak and the Pole about Morris. They said he had not been at the warehouse for weeks. Yitzhak said Morris had seemed especially agitated. So I left Morris a note, explaining that I'd taken the painting and that he should add it to what I already owed him. Entrusting the note to Yitzhak, I left.

9

THE AFRICANS FROM WHOM I WAS BUYING ART,
including the Diops, kept their art in a storage facility that
occupied an entire block on the far west side of Manhattan.
On the weekend, they would pull out a fraction of it and
display it in the flea. The most valuable pieces were kept in
the storage units. During the week, they and other dealers,
their wives, and their children would gather in a clearing on
the first floor. There they would make lunch and exchange
news about what was happening in Mali, Burkina Faso, the
Ivory Coast, and Ghana. Frequently they would perform re-
ligious ceremonies or, if they were Muslim, pray on rugs set
up in a corner.

One of the Africans had a unit filled with old records and
CDs from Africa, and he would play them so that they could
be heard throughout the floor. Much of the music was meant
for dancing, and in the late afternoon many of the men and
women would dance.

One day, while listening to the music and looking at Afri-
can sculptures, I ran into Ibrahim, who wanted to show me
something. I expected a boli, but he reached into his pocket

and pulled out a group of photographs. The photographs were no more than four inches tall and three inches wide. They were old portraits of men and women from Mali.

I had little time to look through the photographs but noted that they had been taken by a photographer named Seydou Keita and that the address of Keita's studio, as stamped on the back of the photographs, was down the street from where Ibrahim and his brothers grew up. Those in the photographs wore a variety of attires, some in traditional clothes, others in skintight pants and shirts sitting on motorcycles or holding radios. In all of them, there are the patterned bedsheets that Keita used as a backdrop. The medley of patterns from the clothing and the bedsheets created a hypnotic abstraction. I began to collect Keita's photographs.

Intrigued by the culture of the storage facility, I started spending more and more time there. My expenditures there were considerable. Between the storage facility, Morris's basement, and the flea itself, I was now spending recklessly.

. . . .

ONE OBJECT FROM THE FLEA stood out above the rest in my apartment: the bewitching painting of Frances that I'd found in Morris's basement. Whenever I reached up to take it off the wall, it offered some new part of itself to restrain me. First taken by the formal elements of the painting—color, composition, light, space, and the tensions and harmonies between and within these—my focus shifted to the woman herself and ultimately her eyes, with their sparkling intensity and the question of who she was, why she was sitting in

a naked room, and what or who had caused her to look up from her book.

I became determined to find out who had painted it and the story behind its creation.

Remembering that Morris had told me the previous owner of the painting lived near the corner of Eighty-Fourth and Park Avenue, I took the subway to the Upper East Side. Beginning at the corner of Eighty-Sixth Street, I walked up and down Park Avenue, inquiring of doormen whether they knew of an elderly doctor who had moved to Florida, a doctor with a lisp.

I was determined to continue my interrogation of doormen until the evening, but around four o'clock one of them said that he thought he could help. I waited in the lobby, which was being redecorated, while the doorman made a call.

Ten minutes later, a tall young man wearing a white lab coat appeared. He introduced himself as the doctor's assistant. The young man led me through the lobby, into an office, and down a hallway to a small room. In the room were various medical devices and a large padded chair. The doctor's assistant offered me the chair, which I accepted.

"The doctor will be with you in a couple minutes." And with this the assistant left the room.

The doctor arrived moments later. He shook my hand, gave me his name, which, along with his accent, made me believe that he was originally from India.

"My assistant tells me that you are looking for help," he said.

"Yes," I explained. "I have a painting, a painting to which I am quite attached, of a woman named Frances."

"I can probably help you with that."

This was undoubtedly my man. I moved quickly to complete the story.

"I was told that this painting—"

"What was her name?"

"Frances."

"Who?"

"Frances."

"Slowly, now. Like this: Fran . . . c . . . es!"

With each "Frances" he was closer and closer to my face.

"Fran . . . th . . . ces," I tried, but he now had two fingers inside my mouth.

"To be honest with you," he went on, having extracted his fingers, "I am not certain you have a problem. Nothing a few months with a therapist couldn't clear up."

"Therapist? For what?"

"Your lisp."

What I needed was a therapist to explain how I had become so ridiculous. Ridiculous because I had allowed myself to be seduced by my own conceits of the flea: that it was the avatar of the unknown, and through participation in its mysteries, however small and seemingly insignificant, there was a chance of shedding one's egoism, and this was as near to a numinous experience as one could hope.

Leaving the lobby, I passed the doorman, the well-meaning doorman who believed that I was asking for a doctor who could help me with a lisp. He nodded sympathetically.

· · · ·

I NEEDED MORRIS to find out more about the painting, but Morris hadn't been to the warehouse in nearly a year. With Morris gone, perhaps permanently, I phoned an acquaintance who was a curator at a museum and was said to be an authority on postwar American art. The curator was receptive to the idea of helping me with the painting and invited me to the museum.

I spent the days before my meeting preparing the painting for transportation and inspection. A friend who was a conservationist removed whatever dirt had accumulated on the surface of the painting while it was in Morris's basement. There is also an art to packing paintings so that they are not damaged in transportation. A special wooden frame was constructed around the painting and then the painting and frame were wrapped in protective materials. While this was being done, I prepared the notes I had taken on what I had been told by Morris and various views of the paintings that had been offered by those whom I trusted. As to my own thoughts, I would convey them in the meeting.

Taking a cab to the museum, the painting on my lap, I arrived just before noon. Security at the museum checked the painting, recorded my identity, and then I waited. Soon a woman arrived to escort me and my painting to the meeting. Walking through the halls of the museum, passing some of the most important artworks of the twentieth century and accompanying wall text, I was sure that my questions about the painting were about to be answered.

In a handsome but understated room, I was welcomed by the curator and two of his assistants. He was thin, with curly black hair and the round black glasses associated with Corbusier. A small drawing by Giorgio de Chirico hung on the wall closest to the door. Everything about the office pointed to the curator as a scholar.

As one assistant gently removed the wrapping from the painting and the painting came into view, the curator's eyes became focused and his expression grew serious. He insisted on removing the last layer of packaging himself. His hands were delicate and his gestures careful and practiced.

He bent closely over the painting, raising his glasses from his eyes. The curator needed to have his time with the painting before he announced the importance of what he saw.

He straightened, returned his glasses to his eyes, and addressed me directly and in a quiet voice.

"There is no reason for you to feel embarrassed. You are not the first to bring me something like this."

What was that? I caught the eye of one of his assistants. She turned away.

The curator was now leaning toward the painting. A pencil appeared in his hand. He aimed it at the face of Frances.

"Look at the nose."

The nose?

"The artist was having trouble with it. He wasn't confident in what he was doing, so he repainted it."

Why was he talking about the nose? And why was it important that it had been repainted? Artists are constantly repainting their work.

The curator's pencil had left Frances's face and was moving down her body. I had the urge to seize the pencil and break it.

The pencil stopped at the bottom of the painting, where the woman's arms crossed. "Hands are very difficult," the curator said, now addressing his assistants, "perhaps the most difficult part of the body to paint. It would have made sense for the hands to be holding the book, but the artist knew he couldn't do that well. For this reason, the book sits in the lap and the arms are extended out, leaving the hands out of the painting."

The curator had done our mutual friend a favor by agreeing to look at my painting, and as soon as he saw it (no doubt before the last layer of tissue was removed), he decided that only someone who understood little or nothing of art and who had no appreciation of the demands on his time would insist on bringing such a painting to his office. Making the best of the circumstance, he turned the time he had in the company of the painting and myself into a tutorial for his assistants.

And he was just warming up.

"She appears to be having a conversation with someone about the book. The artist, no doubt. We, the viewer, see her from the perspective of that person. But to see her from that angle, the artist would have to have been below her, near the floor, staring up. It's ridiculous."

He reached toward the painting, raised it, and flipped it around. It was a dramatic gesture, meant, no doubt, to impress his assistants.

He did not deserve to touch this object. Good or bad, it had mattered to a succession of people—the sitter, the artist, the doctor, Morris, and myself—and each had found some-

thing of value in that object. Around the painting, his deli-cate hands were enormous and grotesque.

"Take a look. The board here is cheap, not something a successful artist would use. He was an amateur."

Harold and his Degas pastel came to mind, and I thought about how he felt that day at the auction house.

It was not that the curator was wrong about the painting or even that he was intentionally dismissive; what was trou-bling was the realization that if I had walked in that day with the very same painting and lied about it, telling him it had been authenticated as an early work of de Kooning or that it had come from a Park Avenue estate, the curator would surely have found a dozen reasons to like the painting, to see it as a "transition" piece or to focus less on the unpainted hands and more on the exceptional use of color. The fact that it came from the filthy basement of the flea was damning.

The curator stood.

"I must go," he announced. "And I am sorry that I wasn't able to give you better news."

Sensing my disappointment and possibly my fury, he offered a suggestion.

"Give it to a friend for their birthday."

The curator turned toward the door, leaving his hand on my shoulder for that extra moment that one gives to a criti-cally ill relative.

· · · ·

THAT WINTER I HAD AGREED to host a book party for a friend. Many people were invited, and for two days I had

done nothing but make certain that everything I'd collected was well displayed and accessible should any of the guests want to examine it.

Just before the party, I sat down to take stock of what I had accomplished: my apartment was not unlike the "wonder rooms" in the homes of seventeenth century collectors, where the walls, ceilings, and floor were covered in preserved body parts of animals, including internal organs, as well as paintings, sculptures, icons, musical instruments, dried insects and vegetation, and articles of clothing. In my small living room alone, I had all of these plus photograms (photographs made by placing an object directly onto photosensitive paper and exposing the paper to light), framed frames, shotguns, boxes of photographs from the Middle East at the turn of the century, glass eyes, framed sheets of sandpaper, American flags, Indian miniatures, innumerable boli, marble busts, columns of rugs from North Africa and the Middle East, a sculpture made from a parachute that inflated and deflated every fifteen minutes, bas-reliefs, an antique window from Yemen, and, of course, the thirty-two volumes of the *Encyclopædia Britannica* with the blanket that I'd bought from Alan, which were still residing in the fireplace.

The only object that had any room to itself was the portrait of Frances. That I continued to place above the fireplace, with a border of two feet around it and its own spotlight.

After an hour or two of the party, all was going well.

When I saw a couple looking at the objects around the apartment, I moved across the room to introduce myself and answer the questions they would undoubtedly have:

"Do you plan on donating your collection to a museum?" "Will you publish a catalogue and monograph about these objects?" "How long did it take you to assemble this?"

As I arrived, the woman of the couple turned to me.

"Hoarder!"

As I was recovering from this, my wife pulled up to inform me that the president of the country of Georgia had just arrived in our living room.

Unknown to me, the president of Georgia was a friend of the person whose book was being celebrated, and happened to be in town for a conference at the UN. He had decided to drop by the party.

My wife and I introduced ourselves and directed him to the drink and food. As we spoke, I noticed him examining the apartment. His inspection began with a pygmy sculpture that I had purchased from the Diops. The sculpture, in every other detail appropriate in scale, had a penis four or five times larger than one would expect from a human of that size.

From the pygmy, the president's eyes moved to the portrait of Frances. From the expression in his eyes, I could tell he found the picture as attractive as I had. I volunteered the story of Morris, the doctor with the lisp, and the perplexing angle from which the artist chose to paint the woman. Having covered the broad points, I then plunged into a too-long description of how the painting appeared to be at the cusp of modern painting, with its use of color, light, and dimension.

Before I could finish, the president's eyes jumped to a different portrait and then to the shotguns in the corner. Underneath them was a rubber mat that contained an impression of a manhole cover. The artist who created it had given me one of the shotguns. This was just before he was arrested for firing a revolver while riding his motorcycle. He was also responsible for the parachute breathing in the corner. The concept behind the sculpture had escaped me but I offered to speak to the artist (who had recently been released from jail) and send the explanation along to the president.

Given that I'd been accused of hoarding, I felt the need to justify each of the items in my home.

"Shit!" the Georgian interrupted.

"Excuse me?"

"Shit."

Since this was all he had said since he'd entered my apartment and since I knew rather little about the man, this declaration was ambiguous. He might, for instance, have been saying that the disproportionate size of the pygmy penis would not seem so surprising if I'd lived in Georgia. Or was it that the pygmy, along with the rest of my art, was not quite up to the art that he had expected to find on a visit to the United States? Or, more likely, was he too accusing me of hoarding?

As I was attempting to sort through this, my wife observed that "someone" (undoubtedly me) had set a candle under the boli, which, after two hours of warming, was spraying the party with the perfume of human excrement.

The next afternoon, battered by the humiliations from the party, I gathered myself and returned to the storage facility in West Chelsea where the Africans kept their goods. There I arranged for a large room, and within a week I had moved everything except two or three objects into storage.

I could not have felt better, cleaner, thinner. It was the great vastation. I was determined to stop going to the flea.

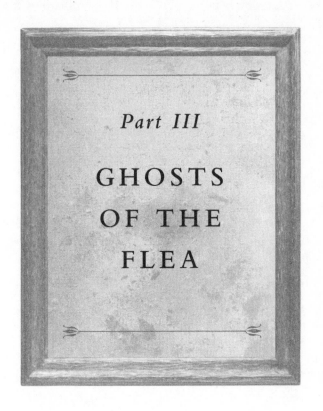

Part III

GHOSTS
OF THE
FLEA

10

MORE THAN A YEAR HAD PASSED SINCE MY LAST
visit to the flea. I had returned to much of what had occu-
pied me before I'd entered the garage. But those activities,
however worthy or satisfying they had once seemed to me,
were now a gnawing nullity. I persisted, hoping that I would
forget what I had encountered in the flea. It was around this
time that I got a call from the Prophet. He said he needed
to speak to me, but it had to be in person. He suggested we
meet at a café in Chelsea but not too close to the flea. The
Prophet knew I had stopped going to the flea as an attempt
to break my obsession. Since I'd put everything into storage
and not been back to the flea, I'd felt a sense of loss—not
necessarily of collecting and its excitements, but of the pious
society of the flea and its people.

On my way to meet the Prophet, I noticed a scrum of
individuals on the corner of Twenty-Fifth Street and Sev-
enth Avenue. They were bent over a box, pushing each other
to see what was inside. Next to them, sitting in a folding
chair, sat a calm, pensive figure. Beneath him was a dog,

which he petted. The dog was as indifferent as the man to what was going on with the others.

The man's name was Andrew, and his dog was Nathan. Andrew was one of those vendors who set up on the sidewalks in and around the flea. There the vendors were able to sell their goods without paying rent but risked being chased off by police or store owners. Because they might have to move quickly, they sold only a limited number of items.

Andrew was easily recognized, for he wore, regardless of the season, the same uniform: faded khaki pants, which might well have been left over from his days at Exeter, a black T-shirt, maroon-tinted glasses, work boots, and a chocolate-colored fedora. He had a prominent jaw and an athletic build. His lip hoisted a large mustache.

I'd met him early in my flea-going days, and had relished the story of how he'd ended up as a sidewalk vendor. Years before, he'd been working in an investment bank in Boston. One day, Andrew was driving to his office in Boston when he noticed a store that he had not seen before. Not a new store; one he'd simply failed to notice before, which was curious because it was on his regular route to work. The store was run by the Salvation Army and sold used items at very low prices. He stopped his sports car, turned around, and returned home.

Hours later, he pulled up to the front of the store, opened his trunk, and unloaded five suitcases. He pulled from those cases expensive jackets, handmade shoes, and a topcoat. It had struck him that winter was soon coming, and he hardly ever wore these garments, and he suspected that there were people who could use them.

Driving to work the next day, he noticed that the Salvation Army was displaying his clothing in the window. He stopped his car to look at who was coming into the store, and as he sat there, he saw people buying his clothes and he thought about what other things these people might need. It occurred to him that he had kitchen appliances that were of little use to him; so he went back to his apartment and loaded those into his car. Soon he returned with most of his kitchen, and thereafter, his furniture.

The day after he finished at the Salvation Army, he returned to his office and announced that he was quitting his job. Several weeks later, he moved to New York.

He knew an artist who lived in the Chelsea Hotel. The artist arranged a room for him. Soon he had many friends, to whom he was always willing to give his time. He helped them when they needed financial advice and when they were sick. To several who needed money, he gave money. His help meant that they were able to pay their rent for years beyond what they might have been.

When he ran out of money and was behind on his own rent, the hotel insisted that he vacate his apartment. The day after his farewell party, which was held in the lobby of the hotel, his friends in the hotel snuck him into vacant rooms. He lived like this until he was discovered by the management.

Attached to the hotel and his friends there, he would come into the lobby late at night, chat with friends, read a book, and then fall asleep in the large red chair in the corner, which happened to be a perfect chair for sleeping. The night staff liked him and let him sleep there.

With him always was his dog, Nathan, who was as handsome and sweet as his master. No parent ever worried about their children playing with Nathan, for the parents understood that his jaws were only dangerous if someone approached his master when he was sleeping in the lobby.

During this time, he studied Laozi, coming to understand his attachment to what he referred to as "self-gratification" and how deeply it had affected his thoughts and the circumstances in which he had lived and worked before he came to New York. The struggle of his studies was extended and painful. There were points when he felt himself disappearing, when he knew that he was so close to nothing that Nathan could no longer feel his touch.

When he needed money to feed himself and Nathan, he would go to the flea, find a rare album others had somehow missed, and sell it to a vintage record store on Twenty-Eighth Street. One day he began to sell at the flea. He would place his boxes on the ground and next to the boxes a folding chair, where he would sit. Under the chair was Nathan. Sometimes he would affix albums to the wall, just above the boxes. The albums on the wall would change, reflecting the variety of his musical interests—Mingus, Scelsi, Desi Arnaz, California punk rock bands—and his appreciation of well-designed covers.

But in time it occurred to him that whenever he had his records up on the wall, his business would increase. From then on, he never put his records on the wall. He understood where money led and saw, from his folding chair, those who were already lost to it, those who, upon noticing the lavender in a Sammy Turner cover, failed to recall

a fresco which they had studied in college or the scent of someone whom they had once loved.

I was glad to see Andrew and was early to meet the Prophet, so I walked over to say hello. As I approached I could see him rotating a vinyl album with one hand while holding the cover of the album with the other. Light from the sun, washing across the surface of the black circle, revealed the most delicate fissures in its otherwise perfect black geometry. The sun suddenly jumped from the album back up to Andrew, painting a nimbus above his head.

I walked toward him, making certain to stay just far enough away so that I would not interrupt him. Still staring into the black circle, without ever greeting me, he said, "2001. *New Boots and Panties!!* The record is in okay condition but that's not what you're after, unless you happen to like Ian Drury, which I don't." He raised the cover above his head, without looking at me or anyone else. "It's the cover. Designed by Peter Blake, who was Drury's teacher at the Royal Academy, the cover is one of his best." He inserted the album into the cover and extended his arm toward me.

"Take it!" he said.

Not to take it would have risked his anger, so I accepted it and headed to my meeting with the Prophet.

· · · ·

WHEN HE SPOTTED THE ALBUM under my arm as I arrived at the café, the Prophet's expression shifted just enough that I knew he suspected I'd broken my oath to stop collecting from the flea.

"It was a present," I assured him.

The Prophet's arms rose slowly from the table, his palms turned downward and his head rolling from side to side. When his head stopped, he was staring into my eyes.

"Don't wait too long to come back to us, for one day there will be a giant hole where the garage is, and when you look inside, all the vendors, past and present, their booths, past and present, and everything they sold or would have sold will be spinning so fast that when you reach out to them, your fingers will melt."

If this had come from anyone other than the Prophet, I would have been disturbed. But the Prophet was always foretelling the end of the flea, and to some extent he was right: the open lots lining Sixth Avenue between Twenty-Third and Twenty-Sixth had all closed in recent years. So as well the small lot on the corner of Sixth Avenue and Seventeenth Street. But the garage and the open lot on Twenty-Fifth Street seemed impregnable.

"There's something else," the Prophet said.

I waited.

"Frank is dead." The Mayor.

I'd heard that Frank had been absent from the garage for a while, but I'd assumed he was spending time with his wife, who was sick and receiving treatments. According to the Prophet, Frank died of a form of cancer that was closely linked to cigar smoke and hair dye.

"They've left his booth empty," the Prophet said, "and the vendors have set up a table with flowers."

The Prophet knew of my affection for Frank. He was

one of the first vendors I came to know at the flea, and he provided me, along with the rest of the flea, with unending entertainment through his impromptu performances. Also, some of my most prized objects had come from Frank, thanks to the trust I had in him and his eye and the variety of objects that crossed his tables. He was also generous with my wife and daughter. And he was, after all, the man who had saved me from being strangled.

I wanted to pay my respects to his old booth right away, so the Prophet and I finished our coffees and walked to the flea.

When the flea opened decades before, the parking spaces in the garage were assigned to whatever vendors showed up that first weekend. No attempt was made to group the vendors by what they sold or the cost of what they sold. This meant that the society of the garage was permanently eclectic, as the vendors settled into their slots and rarely relinquished them. So the vendors, white, African American, and Hispanic, African and Asian, urbanites and country people, came to know each other. They fought with each other but mostly cared for each other, became involved romantically and had children, looked after each other when they were sick and old.

I searched for Paul but was unable to find him. I had heard that he'd not been around for a while. Usually, even when he was away from the flea, Paul and I would speak if he had found an article of clothing that he thought would interest me or when he wanted to bring my attention to a poem or a passage in a book. But I'd not heard from him in a long time.

I bumped into a friend of his named Steve, who was also a vendor, and I asked him about Paul. He said that Paul's

driver's license had been taken away owing to an accident in which Paul was intoxicated. Steve had offered to drive Paul on the weekends, but Paul refused. Steve told me he had been encouraging Paul to go into rehab and hoped that was where he was, though he doubted it. He'd tried to reach Paul in Connecticut, but had not heard back.

I thanked Steve and moved on to Frank's booth. There, as the Prophet had described it, were the table and the flowers, but also a photograph of Frank. He was smiling. He wore the old jacket he always wore and his thinning hair was slicked back. Someone had typed a tribute to him and people in the flea added handwritten notes. As vendors passed the table, they cried.

One does not grow up desiring to be a vendor or picker or hoarder, one does not go to school for it; the flea market is a clearing, found accidentally, on a path to, or away from, some other place. So there is an empathy in that space for those who are unsettled—those for whom life's chaos is more tangible than its certainties.

Leaving the garage from the Twenty-Fourth Street exit, I noticed that the pile on Jokkho's table was particularly full. A closer look revealed that many of the objects had come from Frank. When Frank passed away, Jokkho had purchased what remained of Frank's inventory and was now displaying it.

I purchased some of Frank's items from Jokkho. Whatever progress I had made over the last year in separating myself from the flea ended at that moment.

Objects I had not considered before had come to mind

while I was away from the flea. China plates, fountain pens made in Japan between the wars, used jars of pigment. During the time I had stayed away from the flea, I had no place to find them. Which, of course, was not true. I had innumerable places to find them; it was simply that I did not have the one place to find them where I wanted to find them, namely the flea.

Within four or five months, my apartment exceeded the state it had been in before I had stopped collecting: I had started on a haphazard collection of plates and diagrams of internal organs, and a black bear rug including its head was on the floor of my living room. I had also added during this time oddly shaped rocks, fabrics from Mexico decorated with women spanking each other, a box of ceramic faces, mud paintings, a sculpture in the form of a helium molecule, a tailcoat from the 1940s, and a large door from Marrakesh. When the apartment could hold no more, when I had trouble moving though it, when I stopped inviting people over, I again moved everything into storage. When I inquired of my wife whether any of this troubled her, she remarked that she had long harbored hoarding tendencies of her own (the dozen boxes of hand-carved printing blocks from India suggested as much) and that being around me had cured her of ever wanting to buy anything. As to my daughter, she confessed to finding it less disturbing than other aspects of my character.

For years, the cycle continued: my apartment would fill and then all of it would go into storage, and when the first storage room was at its capacity, I leased a larger one, and

when that one was full, I leased another, each time telling myself that I would stop. But I never did.

I had for so many years of my life rejected objects, living alone with my books and journals. Now I was bulimic: bingeing and purging paintings, sculptures, antiques, and fetish objects.

11

A FEW WEEKS AFTER MY VISIT TO FRANK'S BOOTH, the Prophet asked me to meet him in the garage, and it sounded urgent. Because it was early Sunday morning, when the vendors were unpacking and the only other people in the lot were pickers, I guessed that he was in a skirmish with Grandpa again, or with another rival.

I found him standing in the booth of the Diops, who were setting up. The Prophet's eyes moved back and forth across the lot.

"You can't imagine," he began.

The Prophet's mind was filled with enemies. He had told me that if he was going to be attacked, the booth of the Diop brothers, with its clubs and shields, was the place to defend himself. The Diops, in turn, were interested in protecting the Prophet from Grandpa and the others because they believed in divination and considered the Prophet to be a diviner.

I agreed, knowing that one day the Prophet—standing in the middle of the flea, incanting prices from auctions, his arms stabbing the air—would come upon the sequence of numbers

and gestures that would cause Sophia's child to be brought back to life, Jokkho's eye to grow back, the Dane's dissertation to be finished, and the flea to be saved. The latter would be the most difficult: in my two decades in the flea, the number of vendors had dropped from twelve hundred to fifty.

Those who remained, along with Paul, Morris, Sophia, and the others, were capable of intricate connections to the most maligned objects, including themselves. From this arose a rare light and sympathy that made me feel there was nothing lowly in the world. How to save something so important and yet ephemeral was the mystery.

"Follow me," the Prophet said.

Tugging his cart with the auction records, the Prophet led me out of the lot, across Twenty-Fifth Street, and toward the front door of a late nineteenth century brick building, typical of the older buildings in the neighborhood. I knew that building to house a collection of vendors who sold more expensive versions of what was available in the garage. Vendors in the garage and outdoor lots who had realized some success moved into the building, where the rents were higher. The opposite was also true: vendors who failed in the building set up in the flea.

The Prophet knocked loudly on the glass door. A man appeared and, recognizing the Prophet, unlocked the door.

I followed the Prophet inside and then to the back of the ground floor. A small group had gathered around a U-shaped glass counter.

The secret auction. This was the Prophet's gift to me. The flea's greatest secret—I had wondered about it for years:

where it was, who was involved, whether it ever existed or was a fiction of the flea—and now, suddenly, I was in its midst.

Inside the counter was a man in his mid-fifties and a young woman, possibly Slavic. The man was in jeans that had fallen below his waist and a blue-and-gray-striped shirt. His hair was slightly grayer than the shirt and his eyes bluer.

Next to the man and woman were two tables filled with objects—chandeliers, cigar holders, vases, samovars, bronze sculptures, and paintings. The floor around and underneath the tables was also filled with objects—larger paintings, rolls of fabric, canes. The man and woman, encircled by the glass booth with its many objects, were figures in a snow globe.

The Prophet checked his watch and started twitching.

"If you recognize anything, let me know. But don't speak to anyone but me."

There were some pickers and vendors I recognized from the flea, but most of the people around the booth I did not know.

"Over there . . ." the Prophet said, jagging his head toward a tall, overweight man with a shawl around his shoulders. The corners of the man's mouth were wrinkled and stained from cigarette smoke.

"We call him Kevorkian," the Prophet said. "For years he worked as a nurse, taking care of a rich invalid on the Upper East Side. One day the guy doesn't wake up. No one was ever really sure what caused his death, but the will left everything to the nurse. He hasn't worked since."

A woman in a vintage dress arrived. She threw down her purse and began poking at her phone.

"That's Ethel," the Prophet explained. "He had a gallery uptown. His parents were wealthy Jewish collectors, who financed the gallery. When Daddy died, the son closed the gallery and dropped out. Now he's back as a woman."

"And an attractive one," I noted.

"Not my type," replied the Prophet. "But she's nice and smart. She loves Judaica. Especially menorahs. And she has lots of money to pay for them."

I didn't have to ask the Prophet about the hissing figure directly across from us.

"Grandpa!" he said with a snort. To his side were three men in their thirties.

"Drug dealers," the Prophet whispered. "They live upstate and use the money they make from meth to buy expensive paintings."

Someone came up from behind us and said something in the Prophet's ear.

I recognized him but had never met him. With his round glasses, pocket square, and sports coat, he had a look of respectability, and people, in turn, seemed to know and respect him; as he passed, they made sure to say hello or shake his hand.

"This is Bobby," the Prophet said as he introduced us. "But David calls him BBQ. He has a space in this building. You should visit." This was the Bobby whom I'd met years earlier, the Bobby who regularly gave money and paintings to Eve when she needed help.

I asked why David called him BBQ.

"Who the hell knows?" Bobby said. "David has a name for everyone."

David was the man in the globe. The mysterious auctioneer.

. . . .

THAT FIRST DAY I met David, I had no idea who he was other than a figure who floated through the flea, barely visible except to those who knew him from the auction. But one day soon after, I happened to encounter him at the flea. He was sitting alone in the accumulation he would soon sell, staring beyond it to the accumulations of the other vendors and beyond those to the objects set up in the parking lot across the street. The sea of objects undulated as vendors moved them, elevated them, and as the objects, in reciprocation, gathered about the sellers, comforting them, distracting them from their mortal concerns.

As we spoke, I learned that David had grown up in Berkeley in the sixties. Behind his family's house was a garage, and above the garage was a guest room. David's parents would rent out the guest room to graduate students, who'd help look after David and his sister.

Not long after David's parents divorced, David's mother became involved with one of the graduate students. That fellow would take weekend trips to the flea markets. David would go with him. Fascinated by what he saw, David began going by himself.

When David was still living with his mother, he and his

mother left California for St. Louis. The neighborhood where David and his mother lived was where my wife was born and was ten minutes from where Paul the haberdasher claimed his family lived. Nearby was Alexander's Antiques and Furniture, which was owned by a man named Red who bought and sold the estates of those who owned the old mansions of Forest Park, a wealthy neighborhood dating back to the mid-nineteenth century.

Each day David would ride his bicycle to Red's, and Red would teach David the business of buying and selling estates.

"The guys coming in to buy the estates were smart, tough dealers from rural Missouri," David recalled. "But there were also smart, tough black guys from East St. Louis. Everyone was packing weapons, and a couple of the guys came with shotguns strapped to their backs. Red would hold auctions, but often the guys with guns would just grab stuff, throw money down, and walk out. No bidding. No negotiating. Nothing. They paid what they wanted to pay and left."

David moved from St. Louis to New York when he was sixteen.

As soon as he arrived in the city, he found the flea markets, and as soon as he found the flea markets, he realized that what was being sold at the flea markets in New York—antiques, rugs, secondhand clothes, and jewelry—was pretty much the same stuff that Red and others sold in St. Louis. Soon he started placing ads in newspapers, offering to buy estates. Unlike others in the estates business, David, following Red's example, was willing to buy everything in an estate, down to the boxes of crayons.

If the estate was too expensive for David, he would wait until other liquidators bought what they wanted, and he would buy what was left. It was not uncommon for him to discover something of value in those piles of what were thought by others to be junk. David also said that, unlike others who were buying estates, he was willing to take the time "to look under the bed"—a strategy he also picked up from Red. It was often there—under the sink, at the back of a closet, in the basement, air shaft, or garage—that he would find the best parts of the estate.

On weekends, David would take a booth at a flea market on the Upper West Side, where he would sell what he had bought during the week.

But if the buying and selling of estates was what supported David, it was not what he wanted in his future. David wanted to be a stand-up comic.

"I was a regular at the Village Gate and made enough to support myself," David explained. "In the early eighties, people doing stand-up all knew each other because there were only a handful of clubs.

"But at the end of the eighties, there was a boom in the stand-up business and suddenly there were so many people doing stand-up that it was impossible for me to make a living. I was making more by buying and selling in the flea than I was at the Village Gate. So I quit stand-up."

With his success in selling antiques, David eventually opened a store on Madison Avenue and devoted himself, day and night, to making it a success.

"At my store, I was selling high-quality paintings and fur-

niture at reasonable prices. But no one was buying from me. Every day I would come into the store and think, *How can I make my store nicer and my paintings and antiques less expensive?* Then it occurred to me: these people didn't want antiques and paintings at reasonable prices. An elegant nineteenth-century watercolor at a good price didn't do it for them. They wanted big, recognizable, and overpriced paintings."

So David closed his shop and returned to California, convinced that people there would be more interested in what he had to sell.

"At first I didn't make money. But I persisted. I imagined one day telling the story to my kids of how through hard work I became a success. I liked the idea of telling that story.

"I worked harder and harder until finally one day I found myself down to five hundred dollars in my bank account. Desperate, I withdrew the five hundred and paid the fees for the test that would get me into law school. I didn't want to be a lawyer, but it was the only way I could see to make steady money.

"Because I wanted to get into the best law school possible, I put a lot of effort into preparing for the exam. Besides, I had no money to take the exam a second time."

David sat for the exam on a weekend in the middle of summer. The exam was held in a lecture hall at UCLA. It happened that David knew the lecture hall because he had attended an art class there.

"As I began the test, I realized that all the effort I'd put into studying was worth it. The exam was much less difficult than I'd expected. Halfway through it, they gave us a break

to go to the bathroom. By the time I got there, the line was long. Because I knew the building, I ran up the stairs to the bathroom on the third floor."

By this point in the conversation, David was slumped in his chair, his legs crossed and his body extended to the point where he was nearly flat. He continued:

"Walking down the hall to the bathroom, I noticed that one of the classrooms was open. Inside I see a bunch of things in the middle of the room—chairs, desks, boards, a rolled-up rug—and next to the pile is a sign, which says that the university is remodeling the building and that things in the pile are for anyone who wants them. No charge.

"I continue on, but just as I'm entering the bathroom, I think, *Wait a minute, wasn't that a Tabriz?* But I was a good thirty feet from the rug when I'd spotted it, so I walked back to the classroom and confirmed that it was what I thought— handmade, old, and undoubtedly Tabriz. There were falcons and the color was a worn ruby.

"Within a couple minutes I'm back at my seat in the lecture hall, filling in the dots on the answer sheet, confident that the afternoon part of the exam is going to be as easy as the morning, when I hear a voice. *David*, the voice whispers, so as not to disturb the others, *you can finish the exam and become a lawyer, get that job at a big law firm, and buy a beautiful old house (just like the ones you used to visit in St. Louis), or you can get up, go back upstairs, pull out the rug, and drag it to your car.*"

David paused, reflecting on the serendipity of coming across a rug from Tabriz in a UCLA classroom on his way to a bathroom in the middle of the law school admission exam.

"I left my seat, got the rug, and a few days later, sold it. With the couple thousand I made from the rug, I bought a ticket back to New York. As soon as I landed, I headed to the flea."

. . . .

AT EXACTLY EIGHT O'CLOCK on the Sunday morning when the Prophet first brought me to the snow globe, David waved a vase above his head. With that gesture, all conversation around the counter stopped.

"An obviously large vase," David began, quietly and in a scholarly tone. "It is, I assure you, heavy. I bring your attention to its naturalistic decoration, a decoration which is only possible by the most skilled glassblowers. If you cannot see it from the back of the room, the decoration looks like a decayed tooth. Possibly a molar. The perfect present for your dentist."

The crowd on the other side of the counter was laughing at the vase.

"I'll start the bidding at eight dollars."

"Eight-fifty," yelled out a man next to me.

"Fifty dollars," from a young woman on the other side of the room.

"Seventy-five," the man called out.

"Eighty." This from Grandpa.

The bids worked their way up to $100 and there they stalled.

"What's going on here?" David shouted. "At a respectable auction house, this vase would go for thousands!"

The bidding jumped to $120.

Just as it appeared that Ethel, who put in the bid for $120, would take the vase, Bobby cried out:

"One thousand dollars!"

"BBQ!" shouted David.

David quickly surveyed the room, attempting to find another bid.

Nothing.

"Going once," David cried.

"Going twice . . ."

"Thirteen hundred!" Bobby yelled.

David ignored him. The Prophet turned to me.

"Did I mention that Bobby is bipolar, possibly a residual schizophrenic?"

He hadn't mentioned anything about Bobby, other than that David called him BBQ.

"He's often just giving away his money to people in the flea. Classic bipolar. Or spends money he doesn't have. Ditto."

David looked for another bid.

"Fifteen hundred." Again from Bobby.

David paused, scanning the room for another bid.

"Are you deaf?" Bobby yelled at David. "I bid fifteen hundred."

"All right. Fifteen hundred!" David replied. "At this point, the house is required by its own code of ethics . . ."

Laughter from the crowd. Ignoring it.

" . . . to inform Bobby that he is bidding against himself."

"Then do I get it for thirteen hundred?" Bobby asked.

"Sadly, no."

More laughter from the crowd.

Handing the vase to his assistant, who jotted on a pad that Bobby was the high bidder, David searched the piles around his legs for his next offering.

This gave the Prophet time to tell me about Bobby.

"He was beautiful, young, and gay. Walter Chrysler Jr. fell in love with him. Though much older than Bobby, Chrysler shared Bobby's interest in art and antiques. With support from Chrysler, Bobby was able to set up a gallery. When Chrysler died in 1988, it was rumored that he left Bobby his money. He spent all of it on alcohol and drugs."

David lifted a large framed landscape.

"A Dutch landscape. It once hung in an apartment of an old man on Fifth Avenue. It took me years to get it from him."

"You slept with him! Admit it, you slut!" This from a short, muscular man in a tank top and red, white, and blue flip-flops.

Everyone knew the man. Vinnie was a dealer in European and Middle Eastern antiquities and spent as much as anyone, if not more, at David's auctions. But he also had a special interest in taunting David.

"Vinnie, I am, as always, thankful for your insights," David replied.

"May I see the painting?" the Prophet asked.

David passed the painting across the counter to the Prophet.

Others—understanding that the Prophet would not ask to see a painting if he wasn't interested in buying it and that he

wouldn't be interested in buying it if he didn't think the paint-
ing was important—began calling out to see the painting.

The Prophet examined the initials on the painting. They
appeared to be "EHK," but they were especially difficult to
read owing to the condition of the painting. The Prophet
needed only an instant.

"Egbert van Heemskerck," he mumbled.

David began:

"I'm going to start the bidding at five hundred dollars."

Silence.

"I said the bidding starts at four hundred dollars."

More silence.

"WAKE UP, YOU PEOPLE!" David screamed.

"Twenty-five dollars." This from a thin elderly man in
the corner.

A smile from David.

"Ladies and gentlemen—Bottom Feeder bids twenty-five
dollars. Don't be intimidated."

"Thirty." This from a woman opposite from Bottom
Feeder.

"Thank you, madam. Do I hear thirty-five?"

"Thirty-five."

"Another bid from Bottom Feeder," cracked David. "He
is the wealthiest person here but hasn't bought a thing since
I opened."

"Forty." From a different man.

Angry at having been outbid, Bottom Feeder stood up and
marched out of the room, knocking over a chair as he left.

"Sorry, Bottom," David yelled after him.

There was scuffling at the corner of the counter. The Terminator (David's nickname for a grim man with thick white hair and black glasses) and a young, pierced woman who had marched over from the other side of the room were shoving each other. The Terminator, attempting to prevent others from seeing the Dutch landscape, had been holding on to it despite being asked by several bidders, including the young woman, to pass it.

"Let go, you old dick," the young woman said as she pulled on the painting with her left hand and struck the Terminator's chest with her right forearm.

"You'll get it when I'm done," returned the Terminator, who, stronger than one would have guessed, kept hold of the painting.

"Screw you." The woman gave the painting a last tug.

The young woman freed the painting from the Terminator.

David, amused, stared at the two of them.

The Prophet bid seventy-five dollars.

The attention around the counter shifted from the struggle over the painting, which continued, to the Prophet's bid.

The bidding quickly jumped to five hundred (owing entirely to the Prophet's interest in the painting). Several more bidders were now in.

The Prophet bid up to eight hundred and then dropped out.

"Two thousand dollars!" shouted the Terminator.

"The Terminator!" called David. "Do I hear twenty-one hundred from your girlfriend?" David remarked sarcastically.

"Three thousand," she cried.

"Three thousand from the girlfriend. Now we're getting somewhere."

There was no one in the room, including those who were bidding, who actually thought the painting was worth anything like that amount. The painting sold for $3,000.

The next item for sale was a bronze container with Chinese markings on the side. It appeared to be old. Without being asked, David passed it across the counter to a smallish figure wearing what, according to the Prophet, was "a Donegal touring cap." Just beneath the brim of the hat were small eyes and inside the eyes were bulbs of blue that lit up as soon as they touched the object.

"The Professor," the Prophet pointed out.

And everyone was staring in the direction of that boyish man, who was examining the container with a loupe.

David retrieved the container from the Professor.

"I am convinced," David announced as he placed the container upside down on top of his head, "that this is important. I was told that it might have been used to hold wine. If you look carefully at the engravings you can see me surrounded by several women."

"Fifty dollars."

"Bottom Feeder," David observed. "Glad to have you back."

Bottom Feeder, having walked off his anger, was standing in a corner of the room. Others quickly tossed bids at David, including Ethel. Bottom marched out when the bidding reached $85.

The bidding climbed to $500.

The Professor now joined in.

"Seven hundred fifty."

"There is no one," the Prophet said in breathless admiration, "smarter about European and Asian bronzes"—or, I would later learn, swords, helmets, and almost any Nazi artifact—"than the Professor. He comes from a wealthy family, buys for his own collection, and lectures at Columbia. When he's not at Sotheby's or teaching, he's in his library reading books on antiques. Wealthy collectors fly him to their homes on their jets. His own collection is worth millions. Probably tens of millions."

The Prophet had made a point of studying the bidders at David's auction, and he knew exactly what they would pay. The Professor, for example, had no interest in reselling what he bought: he had a world-class collection of Nazi bronzes and swords that he would gift to one of the several museums that used him as a consultant. Owing to his wealth and the fact that he was buying for himself, he was in a position to outbid anyone at the auction. According to the Prophet, the Professor felt a surge of power when he held the German weapons.

The Prophet had a strong interest in being friends with the Professor, for the Prophet needed him to appraise bronzes that the Prophet found in the flea.

There is an important understanding at the flea that if you are a picker and you pull an object off a table and don't know what it's worth, you can trust another picker to give you an honest view of its value. Or, to put it another way, you know that the picker won't tell you it's worth $50 and then, after you've returned it to the seller, buy it and resell it for $15,000.

An elderly woman raised her hand.

David was surprised.

"Mrs. Bottom Feeder?"

"I bid one thousand dollars."

"Does Bottom know you are bidding?" David asked gently.

Silence.

"Mrs. Bottom, you can tell me. I won't tell anyone," David coaxed. The others around the glass counter nodded.

"No," admitted Mrs. Bottom Feeder.

"I'll let you bid, of course, but if Bottom finds out and is angry at you, please call me," David offered. "I'll speak with him. Make sure you leave his number with my assistant."

"Thank you, David."

It was a sweet moment, and everyone took a second to examine the figment of David as psychoanalyst, sitting across from Bottom Feeder, who was on a sofa as David got at the root of Bottom's unwillingness to spend more than $80 at David's auction and then, having dug up that weed, turned to Bottom's long-standing irritation at his wife's habit of treating her best friend, Ethel, to dinner.

David addressed the crowd.

"I've done no research on this, but if you are interested in my opinion, I would say this is worth at least—"

"Five thousand dollars," a woman interrupted.

David: "Exactly what I was about to say!"

Laughter.

Two Asian men, on opposite sides of the counter, jumped into the bidding, working the price to $7,000.

When it appeared that one of the men would take the

bronze container at $8,200, a voice came from the center of the horseshoe.

"Twelve thousand."

David whirled around, identifying the high bidder to the rest of the room.

"The man with the strange beard bids twelve thousand dollars!"

The bidding continued until it exceeded $50,000.

The last bidders were Ethel and one of the Asian men.

The Asian man took it. David passed the container to his assistant, who noted the winner in her log.

Meanwhile, David was examining a small painting on a wood panel.

"Mary, surrounded by angels," David explained. "The wood is falling apart, and it looks as if someone has attempted to repaint part of the sky. The last time I saw something this ugly—"

The bidding began before David could finish.

David caught Bobby running his hands across the panel.

"BBQ," David shouted, "get your hands off the painting!"

"Stop calling me BBQ!"

A man bid $200. The Prophet said he was from Morocco.

Bobby bid $250. The Moroccan asked David whether he knew how old the painting was.

"Maybe sixteenth century," David replied. "Maybe yesterday."

"Going once to Bobby G," David continued, using a new name for Bobby.

"Don't ever call me Bobby G!"

Shaking his head, David continued.

"Going twice to the man in the red corduroy pants."

"I don't like that either, and they're rust, not red," Bobby corrected.

"What do you want me to call you, then?"

"Nothing."

"Why?"

"Because I don't want to be associated with your crap."

"Sold!" David cried. "To Nothing, for nothing."

12

IN THE WEEKS AFTER MY FIRST AUCTION AT DAVID'S
and for years to follow, I did not miss the Sunday morning
secret auction. Since people would bid in after the Prophet,
knowing that he would only commit money to an object he
knew to be valuable, the Prophet used me to bid for him.
The Prophet, in exchange, would help me with illegible sig-
natures and monograms. If we were interested in the same
object, one of us would defer to the other.

At the same time, my knowledge of the habits of the
other bidders increased. Some would only go after objects
they knew well; others, like the Dane, would bid on any-
thing, using intuition to guide them. Some were buying
to fill out collections; others were bidding for customers.
Some could be intimidated by aggressive bidding; others
were encouraged by it.

As interesting as this became for me and as much as I
appreciated what I bought, which was quite a bit, it was the
event itself as orchestrated by David that kept me there. It
was, in David's own description, "improvisational theater,"
the "Wild West of auctions," with David as ironic circus host.

During the week, I would visit David at his booth, discussing the people who attended the auction. Rarely, however, did David mention what he had sold or would be selling.

If he was asked whether he thought a particular object was valuable, he would respond:

"Maybe yes. Maybe no. If I had to guess, I would say it was genuine. But it could just as well be fake."

David had no desire to be an authority on art.

"If I know what the piece is, I lose interest," he told me. "The only things I hang in my home are things I can't figure out."

As to how his auction got started:

"When I began selling at this little glass booth of mine, I didn't have the auction. I would pull my car up front, and before I could get things from my trunk into the building, pickers would yell out, 'Me,' which meant that they were buying the item I was dragging on the sidewalk.

"They didn't even know the price when they yelled out. They trusted that I would give them a fair price, and they knew that if they waited until I had time to think about the price, someone else would buy it."

So why the auction?

"The pickers started fighting. They would get into it over who had yelled out, 'Me,' first. I referred to these as the 'me wars,' and to tell you the truth, it didn't bother me. But the people who owned the building objected to grown men and women cursing and hitting each other in front of the building.

"One day the owner of the building came to me and said that the me wars had to stop or I was going to be kicked out of

the building. At that point, I began bringing whatever I was selling into the building during the week. Then, very early Sunday morning, before the building opened, I would allow the pickers and dealers into the building, and I would hold the auction. I didn't tell anyone what I was auctioning beforehand, so the first time they were seeing it was when I pulled it up from under the counter."

"The Prophet said the pickers hated it," I said.

"At first they did," David conceded. "But they showed up anyway. And still they fought with each other, but at least it was inside and at an hour when no one else was there. And pretty soon things turned: pickers and dealers are competitive and this became a sort of crazy game for them.

"A couple months before, I had a painting that appeared to be a Albert Pinkham Ryder, who painted around the Civil War and is one of the most forged artists. A real one can go for over a million. There are a ton of fakes, some made by Ryder's own assistant. To tell the difference you have to know the chemicals in his paints, which he made himself and often mixed with dirt, and know how those paints hold up over the hundred years since his death. X-rays help.

"It can take years of research and testing to know if you have a Ryder, and the guys at my auction have to decide in a minute or less how much they are going to spend. So they look for clues—in the art, in the mood of the room, in the faces of the other pickers.

"It's high-stakes poker. And one of the great things about my auction is that, unlike other auctions, where the auction house has everything on consignment, I own what I'm

selling, so I have no obligation to say anything or even sell anything. Instead of giving pretentious explanations of what everything is and where it came from, I can tell jokes, be as lazy as I want, and let the pickers and dealers figure things out on the fly."

"The Prophet has a different explanation," I interjected.

"What's that?"

"He says that you like turmoil more than money."

David stopped to think on this. Then he responded.

"I go into the garage and I see two things I like. They are identical. They have no labels. Where they come from, I don't know. If I ask, I get a story from the guy who is selling it—a great story, an unexpected story. But is it true? Who knows? I buy them both. Two weeks later, I sell one for nothing. Two weeks after that, the second one goes for ten thousand. I love that. The flea is a place of uncertainty— maybe the last. If the Prophet thinks that's neurotic, maybe he's right; then again, maybe he's wrong, and it's the Prophet and the rest of the world that's mad."

That made David laugh.

· · · ·

AS MY EXPENSES from purchases at the flea climbed, heedless of the money to support them, I became determined to get control of my obsession. It was here that the Prophet's background as a psychiatrist could prove useful. I arranged to meet after the flea closed on Sunday.

When I arrived at the café, the Prophet was more agitated than usual.

"The garage is closing," he blurted. "Someone bought it for seventy million dollars and they're going to tear it down."

He paused to allow me to absorb this. While the Prophet had long warned of the end of the flea, this was the first time he had anything like details.

"Some of the vendors will go to the open lot on Twenty-Fifth Street, some will stop selling and try something else. But everyone will feel it. When groups are together for as long as these people have been in the garage, there's a lot of morbidity when they separate. You see it in Africa, with people moving around because of war and famine. There was a study in the eighties . . ."

The Prophet stopped. He could no longer carry the weight of this. His arms were quivering. The skin on his face shook. The tears splashed to the sides.

When he had composed himself, I began.

"Prophet, I need help. Something to break my compulsion."

The Prophet's response was immediate.

"Here's what I suggest. Focus on one thing that you have that could be of value—the painting of the woman. I'll help you with that. You and I will do the research. Once we establish who the painter is and get it authenticated, you put it up at Sotheby's. With the money you make, move out of New York."

The plan was sensible. I had lived abroad for many years and, other than the flea, had no real attachment to New York. My wife and I had talked about Argentina. But what would I do with the space the flea had occupied in my thoughts?

After twenty years in the flea, my consciousness was largely defined by my interaction with the vendors and their strange and chaotic bounty.

I turned back to the mystery of the painting of Frances. I'd run out of clues, save one: Morris's remark that he thought the artist had been in World War II. If there was anyone who would be able to give me a list of artists who had fought in the war, it was the Prophet.

The Prophet began reciting artists. But the artists he named were ones I'd looked into already and rejected—wrong style, wrong subject, wrong years, wrong palette, wrong materials. This led me to the thought that the artist may have been drafted but never left the States and hence did not appear in the articles the Prophet had read on painters who had fought in World War II.

As we parted, I thought what I thought every time he walked away, but this time more powerfully—that he was someone a smart and objective observer (the curator I'd met with, the gallery owner that Harold encountered, the collectors I saw coming and going from the museums and galleries) would dismiss as odd and insignificant, with his paintings he buys for $70 and sells for not much more, his shopping cart of auction records, and his shaking and sniffing. None of them would understand that this person existed only because of the flea. He was its magus—the interpreter of its signs and the forecaster of its future.

My first stop was the New York Public Library. There was a special room there that was devoted to research on art, and through the assistance of the librarians, I would

be able to quicken my search. I spent weeks there reading through scholarly books, articles, pamphlets, and monographs on artists of the thirties, forties, and fifties, but I found nothing.

When I had exhausted what I thought might be useful at the public library, I started in on the bookstores in New York that held significant collections of art books. At the time, there were a number that dealt exclusively in such books, both new and used, and the staffs of those stores were often quite knowledgeable. Indeed, many of them had been scholars who, but for a torque in their lives, would have been lecturing at a university.

When I traveled, I sought out libraries, read scholarly articles, talked to librarians, and called those scholars whose work might lead me to the answer of who painted the portrait in my living room. When the libraries closed in the late afternoon, I headed to the local bookstores.

Not infrequently I would phone someone who had written a book or article and question them about the painting. The conversation would always begin with my description of the painting and what I'd been told about the artist. The scholar would politely tell me that they knew nothing especially helpful, but would occasionally offer me the names of one or two artists. Mostly we ended up talking about their publications and the status of their own research.

It was all interesting, but I held a suspicion that the painting was not what I wanted it to be. It had become another symbol for me of my belief in the flea, of my conviction that the flea was something more than how others saw it: the

oddity, the weekend amusement, an object lesson in what happened to people when they refused to adapt.

At the same time, I wondered whether my involvement with the flea was meant to obscure what was happening in Nebraska, including the long sicknesses and deaths of my parents. Those parents, who were from the Midwest, rooted in old Midwestern families, and who had stayed in the Midwest to raise their children and live out their lives, were the reason I was interested in art. My father was an amateur painter and jewelry maker. And my mother spent a good deal of her time taking and developing photographs. She also tried her hand at copper enameling as well as applying decorative tiles to tables and counters. My parents practiced their arts in the basement of our house in Omaha. Every so often they would create something that they thought was exceptional and would bring it upstairs for us to see.

· · · ·

ON JULY 14, my father's birthday, my wife and I decided to have drinks at one of his favorite bars in New York. That bar was in a hotel on the Upper East Side, near where he and my mother stayed when they visited New York. I'd not been to the bar in years and, while gazing around, noticed a sign discreetly placed in the hallway near the door. It noted that a shop selling prints and books was located on the second floor.

I returned the next day. The store specialized in illustrated books and manuscripts from the Renaissance onward, as well as fine and rare copies of books on art, architecture, and natural history. Not exactly what I was looking for, but

I had exhausted all other stores in New York, and were I to abandon my search for the person who painted the woman, a bookstore above a bar seemed the best, last stop.

The store had comfortable chairs and large empty tables for stacking books or portfolios. The staff was knowledgeable but, as with the other bookstores and libraries, nothing was helpful to my search. Just before the shop closed, and hurrying to pack my notebooks, I dropped my pen. Bending to pick it up, I noticed a shelf of books. Each book bore the name of a single painter—Sam Francis.

A charge ran through me. Was it possible that "Frances" was not the woman in the painting . . . but the name of the painter? It was extremely unlikely. Sam Francis was a postwar American artist known for his abstract paintings, especially those in which the greater part of the canvas was left empty, with paint confined to the edges.

Returning to the bookstore when it opened the next day, I went through the books, monographs, and gallery materials on Sam Francis. I learned that he was born and raised in San Mateo, California. In 1943, he joined the Air Force. But he never made it to the war. While training in California, his plane crashed. His back was broken; he spent the rest of the war in a hospital in California. In a body cast, he couldn't leave his bed.

Once the cast came off and he had recuperated, he left California for Paris and then Japan. He eventually became known for large abstract paintings, the centers of which were left empty. Those canvases were greatly coveted by museums

and collectors. One was chosen by the Obamas to hang in the White House.

Further reading led me to the story of how he had become an artist. In the hospital, confined to the body cast, he was severely depressed. A girl he had known from high school came to visit him and, knowing his mood, thought he should do something to occupy his mind. Since he could still move his arms, she suggested painting.

The girl found him a teacher. That teacher, David Park, taught at the California School of Fine Arts and was himself a respected artist.

So while facedown on the hospital bed and with wood panels lying beneath him on the floor, he began to paint. Freed from the cast, Francis married the girl. The marriage did not last long. When Francis moved to Europe, he stored his paintings at his father's house. When his father's house was destroyed by fire, the paintings were lost.

Before returning the books on Francis to the shelf of the bookstore, I glanced through the photographs at the back of one of the books: of Francis in uniform, another of the artist in his studio in Paris, and one of a young woman, attractive with purple eyes and curly black hair. The young woman's beauty was brightened by the intelligence of her expression.

She was the sort of young woman who, learning that a friend was lying injured in a hospital bed, would come to the hospital with a cactus and an anthology of poetry. The sort of young woman an artist would feel compelled to paint as he gazed up at her from his hospital bed and whom he would

marry when he was able to leave the hospital. She was, without question, the woman in the painting.

As soon as I returned to the hotel, I began researching her name. For a small fee, there were companies that would comb telephone directories, court records, and other sources. I paid the fees, and each day, names, numbers, and addresses would be sent to me. I wrote letters and left phone messages with these women, all the time admitting to myself that the woman in the painting, like Francis, was almost surely no longer alive.

Nothing mattered to me at this point but the woman. Each day, I came back to my apartment, hoping for a response from the woman in the painting. After three weeks, there were no more numbers to call, and no one had responded.

Two weeks later, a woman called from California. Her voice was old but solid. I explained that I had called about a portrait that had been painted many years before.

"Could you describe it?" she asked.

"The woman in the painting is young. Her hair is shoulder-length, thick and curly. She is sitting in a chair . . ."

There was nothing on the other end of the phone. I was certain she had hung up. Then her voice.

"With a book on her lap?"

Now I was silent.

"And a cactus in the corner?"

After nearly fifteen years of searching, I had found her. We shared a rapturous transport: she to the present, I to the past.

She explained that she was the young woman who had

introduced Francis to painting, who had brought him the art teacher David Park, and whom Francis, in turn, painted from his bed in the hospital and later married. She remembered the painting well, as the artist had given it to her before he left the hospital.

For that reason, the painting escaped the fire at the house of Sam Francis's father. The woman had lost touch with Francis after they divorced. She kept the painting for a while and then gave it away. That might have been thirty years ago, maybe more. The painting migrated across the country, ending up in the home of a doctor on the Upper East Side, and ultimately the flea.

．　．　．　．

THE NEXT DAY, as I was sitting at a table in a café planning to head over to David's, Bobby suddenly joined me. He placed a large vase in front of me. It was the vase that David had joked about at my first auction, the one Bobby had bid more for than what was necessary to win.

"Those idiots"—presumably the others at the auction, including me—"know nothing about glass or vases. This vase could have taken months to make. They don't understand its complexity and beauty or how it affects people. I needed to make the point."

I lifted the vase off the table and examined it. Bobby was right. The sides of the vase were etched in an infinite number of horizontal ridges. The shape was sensuous and perfectly symmetrical. Inside the walls of the glass were two dark red abstract forms. There was a signature scratched into

the bottom of the vase, "Tomas Tisch" (one of the greatest living glass artists) and a gallery label, "William Lipton, Asian Art" (a respected Upper East Side gallery). Bobby may well have been bipolar and schizophrenic, as the Prophet diagnosed, but he still made money on the vase.

"I know they laugh at me," Bobby said as I finished my coffee and got up to leave. "But I don't have to worry about them anymore. The auction is shutting down."

I left Bobby for David. Finding him behind the glass booth, I repeated what Bobby had just told me.

David confirmed it.

The problem was that the other dealers in the antiques building, jealous of David's success, had convinced the owner of the building to throw David out. David didn't know where he was going, but he was not disturbed.

David had heard that I'd discovered a painting by Sam Francis. He asked me if it was true. When I said that it was, he congratulated me. David liked the idea that such things were buried in the flea. When he asked me what I was going to do with the painting, I told him that I intended to sell it and move as far from the flea as possible, perhaps out of New York.

As I was leaving David's booth, he stopped me. He rummaged through what he had behind the counter and then lifted up three frames. The frames were badly damaged, irreparably so, and had nothing inside them but the glass. I wasn't interested in the frames, and David knew that. I held the frames up to the light and stared into the glass. On each plate of glass was a faint milky image.

I smiled and asked him what I owed.

"A gift."

"Thank you, David."

Paintings have a life: they crack, fade, shrink, yellow, and bubble. They also breathe fatty acids. Which means that if a painting is sealed behind glass for a sufficient length of time, the acids, evaporating from the painting, will be deposited on the inside of the glass, causing the formation of a whitish film. This is known as blooming or blanching. It is also known as a "ghost image" because the film will sometimes take on the outline of what was in the painting—people, buildings, trees. David knew that I had been collecting glass sheets, preferably in frames, that contained ghosts.

The antiques building was closing for the day. Leaving the building, I stopped to say goodbye to Bobby. He was sitting in the one chair in his shop. The one he wouldn't sell.

He was asleep, his mouth open slightly and his glasses at the end of his nose. It had been too long since Bobby had last dyed his hair. The French cuffs of his shirt were soiled and his knit tie stained. The white handkerchief in the upper pocket of his sports jacket was too small, a cloth cocktail napkin borrowed from a hotel bar. None of this was noticeable when he was awake and speaking. His erudition masked the poverty, the sickness.

As soon as I left the antiques building, frustrated with the pending end of the auction and, ultimately, the flea, I placed the present David had given me, the glass plates, on the sidewalk and walked across them. And when I finished and the three plates were in large shards, I stomped on them again. But the images did not disappear, for they had reconstituted

themselves in a crystal powder that was the amorphous shape of my boot.

I left them on the sidewalk and walked home. Between me and the Chelsea Hotel were all of the parking lots and warehouses that had once been the flea and where I had spent so much of my life. Now David's auction was dead. I had no more desire for ghosts.

13

RETURNING TO THE CHELSEA HOTEL ONE AFTER-
noon, I was handed a note by the woman at the front desk.
It had been dropped off by someone who had not identified
himself. He said I would know who he was.

The note was from Steve, Paul's friend and fellow vendor
from the flea, the Steve who had helped Paul with his alco-
hol and drug problems and had offered to drive Paul and his
clothes to the flea when Paul's license was revoked.

Paul was dead. No more was on the note other than the
name and address of the church for the funeral. My wife and
I decided to go. In Paul's memory, I wore a sports coat and
tie that I had purchased from him at one of my first visits to
his booth.

The church, which was in the style of a ski lodge, had the
advantage of being open to its surroundings, a leafy neigh-
borhood in suburban Connecticut. There was a great deal
of sunlight that day, and a good portion of it had made its
way into the church. Not the sort of setting that I associated
with Paul.

The audience was healthy and good-looking. But part of

this was the number of adolescents at the service—far greater than I would have expected at the funeral of a middle-aged man. But even the older guests were youthful—all in shape, most fresh-faced, as if they'd just come from a good swim.

Among the few elderly at the service was a lone very old woman I understood to be Paul's mother. She showed no emotion, which contrasted with the obvious pain of the younger people. In his eulogy, the brother of the deceased described his sibling as someone who had, all of his life, acted as a teenager—playing games, going barefoot, and joking and giving everyone absurd nicknames.

On the cover of the funeral program was a photograph of Paul with his shirt off, his hair striking the top of his shoulders and a handsome, angular face calmed by the shadows of a late afternoon. Under his palm, a dog.

"Growing up in Greenwich," Paul's brother said in his eulogy, "we had dogs and my brother loved animals. A couple years ago, my brother met Eva and fell in love. When my brother moved into her house, he got to know Eva's horses, including Eddie, a giant, unhappy horse. Everyone in the neighborhood avoided Eddie."

I noticed a man staring at me from across the church. I'd never met this fellow. He was certainly not someone from the flea.

"One day, I came over to visit my brother; and found him in the field behind the house.

"Before I could say anything, from out of nowhere gallops Eddie. He is growling."

A man in a different part of the church was now looking

at the man who had been staring at me. Both had angry expressions.

"As soon as Eddie catches sight of him, my brother races away, and Eddie chases after him. After a minute or two, Eddie backs my brother into a corner of the field. When I think Eddie is about to take a bite out of my brother's head, Eddie drops his snout, taps my brother's shoulder, and runs off to hide behind a tree."

At this point all the men at the funeral service were staring at other men at the funeral service; none were paying any attention to the Eddie story and all were agitated and hostile.

"Finally, my brother approaches the tree, reaches around it, and taps Eddie on the shoulder.

"'Tag, you're it, Eddie,' my brother yells. Now it's Eddie's turn: he taps his hoof three times and gallops down the field."

While the Eddie story was loping along, it occurred to me that the men weren't looking at each other. They were looking at each other's clothing! One of them, in his late seventies, was wearing a gray pin-striped suit with a check shirt and navy-blue knit tie. He was fit and handsome. The suit complemented his gray hair and thin physique. The other man, forty years younger, wore torn jeans, an unstructured sports coat with a shirt open to his muscled chest, and no socks. His skin was dark and his head was shaved. The two things they had in common were their sex and that they shared the same height and build.

On the morning when I first met Paul, the morning when my daughter disappeared into the Lillys, I had wondered how it was that Paul had acquired such fine garments.

Now I had a possible explanation.

During cocktail and dinner parties in Greenwich, Paul might have gone through his friends' closets, removed items that no longer fit them or they weren't wearing or he felt they shouldn't be wearing, and secretly taken the clothes back to his house and given them to other friends who fit into the clothes, would wear them, and should be wearing them. What was left over, he brought to the flea.

It all made sense. Why should a banker in Connecticut keep a silk vest that he doesn't wear because he bought it when he was ten pounds lighter or because he now prefers solids instead of plaids, when that same garment would delight a twenty-four-year-old at the Fashion Institute of Technology or an editorial assistant at an upstart fashion magazine or someone who was spending what was left of his assets on dung sculptures and had a wife from St. Louis, where Paul's family had made their fortune and once lived on a large estate?

So the man staring at me was not staring at me but at my suit—which was really his suit, which I'd purchased from Paul and which, in memory of him, I'd worn to the funeral. And the man looking at the man staring at me was not looking at the man staring at me but at his tie (which Paul had stolen from him). Paul—knowing that at his funeral we would each be wearing something we had purchased from him or that had been given to us by him as a gift, and that we would then all catch on to what he had been doing—had created a giant distraction, a comical confusion, at his own funeral, thus turning what otherwise would be a large and unhappy affair into a large and mirthful affair.

At the train station, waiting on the platform to return to New York, I spotted the black gentleman I'd met on one of my first days at the flea, in Paul's booth. He was wearing a navy-blue suit, white shirt, and suede shoes. The other men at the funeral—similarly well dressed, all no doubt by Paul—were also on the platform. We began to speak to each other about Paul and poetry and clothes, and agreed to get together in memory of Paul. The Assembly of Elegant Men.

· · · ·

WITHIN MONTHS of the announcement that the garage, after three decades, was closing, Paul was dead, Frank was dead, and Mike, the manager of the garage, had died of unknown causes. Bobby became thinner and weaker from the cancer that he had been carrying for so long, and then he too was dead. It was difficult to dismiss the Prophet's suggestion that the destruction of the garage contributed to their deaths.

Some of the vendors in the garage moved to the open parking lot across from the antiques building, which meant they would need to endure the rains and the winters. There would also be fewer sales because the rains and winters kept people away from the lot.

One day not long after Paul's funeral, I was walking down Twenty-Fifth Street when suddenly my eyes filled with dirt. The hot summer's wind had carried the dirt from a construction site. When I cleared my eyes, I saw before me a crater where the garage had been.

I moved to the edge of the hole. At its bottom, giant plows moved back and forth. The vendors, my daughter, my wife,

myself were swept into the burning cloud of dust and gravel. It was the fire of the Prophet's vision.

Something else occurred to me as I stared into this chasm: the fallacy that watching such destruction causes the witness to experience confusion. My thoughts could not have been clearer or more emphatic: concrete and glass would fill the hole; the streets would bring a predictable flow of people into that new building; those people would know nothing of the garage; and the broil of order and death would consume them as it had the garage. I was staring at the combine that had swallowed the child.

The destruction of the garage was an expression of our failure to protect and nurture uncertainty, the mutating salvation which resides within and about us. Whether uncertainty has an existence outside our thoughts or is a category of consciousness, it is fixed to our being, and as such, it responds to, reacts against, historical forces. Giulio Douhet, the Italian whose manuscript I had purchased at the flea, knew this and knew that we could be manipulated by infecting our intimate sense of uncertainty with the threat of immediate and mass annihilation. Consequently, uncertainty became so feared that our instinct is now to turn against it, attack it, and in doing so our thinking stagnates. We lose the ability to adapt, to move forward—to retain the chaos in ourselves that gives birth, in Nietzsche's phrase, to a "dancing star."

Just beyond the crater, I was forced to stop again. An abandoned store had a light on.

A man was sitting inside. It was David, the auctioneer.

He explained that around the time they began tearing

down the garage, he noticed a FOR SALE sign in front of the store. David had never intended to buy a store, but, having been evicted from the antiques building, he needed a place for his auctions. He also liked the idea of being close to what was once the garage.

The people who came to David's auctions liked him. So when he was forced to move, they showed their support by coming to his new location and bringing their friends. Despite this support, many believed that David would have trouble paying for his new space.

It was perhaps with this in mind that, soon after he opened, David decided to gamble on a storage bin that was being auctioned off in Chelsea. The bin had been rented for several years to an art restorer. When the restorer went out of business, leaving a large amount of unpaid rent, the owners of the storage facility put the contents of the bin up for auction.

Without examining the contents, David won the bin at auction for $15,000. He spent several days going through what he had purchased. He discovered a number of large works on paper signed "de Kooning." David began to show the works to those who were considered authorities on de Kooning, but no one would guarantee their authenticity. Whether they did not believe they were de Koonings or whether they feared being sued if they authenticated the works and proved to be wrong, they did not say.

But David believed they were de Koonings, and he offered them for sale as de Koonings. When word of this got out, newspapers ran headlines along the lines of "Junk Dealer Claims to Have Found de Koonings." David seemed

unaffected by these descriptions of who he was and how he did business. But his friends, the dealers and pickers in the flea, were upset, for they understood that David and by implication themselves had spent decades looking at objects, sometimes thousands a week, and that if they made mistakes on what was authentic and what was not, they would have trouble paying rent and feeding their families.

On the day of the auction, everyone from the flea showed up. The crowd was nervous. So too I imagine was David, though he showed no signs of it.

Bidding on the first de Kooning moved quickly at first but what momentum there was fizzled out at $72,000—a fraction of what a de Kooning of that size would bring at an uptown auction house. There was a great deal of disappointment in the room, but no one left David's auction. They hoped that the second de Kooning would produce a better result, even a slightly better result, though the de Koonings were of the same size and quality.

When that painting came up, the bidding began slowly. But after a few minutes, the numbers grew and then a rush of numbers. Suddenly it was over.

"One million two hundred thousand," David called.

But he could barely get this out before the cheers and applause and shouting started. Some began dancing.

And this seemed right. Not only because David had been a vendor and a picker at the flea, nor because David, like other vendors and pickers, had experienced an unusual number of bad times, but because he represented a devotion to the hidden abundance of objects and people the flea sheltered.

Leaving David's new store, I walked to Twenty-Fifth Street between Sixth Avenue and Broadway. Several of the vendors had, as the Prophet foresaw, decided to migrate from the garage to the open lot on Twenty-Fifth Street. Many, though, abandoned the flea altogether, either because the open lot was half the size of the garage and they could not get a space or because they did not want to endure the rain, heat, and cold.

The Prophet had told me that he had seen Jokkho in the open lot just after the garage closed but wasn't sure whether he had decided to remain there. The Diops had set up in the back of the lot, and Paul's friend Steve was just in front of them.

Given Steve's physical similarity to Paul, it was odd to be with him so soon after the funeral. Steve sensed my discomfort.

"Rejoice," he told me, "in man's lovely, peculiar power to choose death."

"Excuse me?" I responded, confused by the reference.

"You didn't know? Paul hung himself. Before he did, he tied an ascot around his neck to make certain that the rope didn't leave marks."

"No one said anything at the funeral," I replied, still dealing with the surprise.

"With his mother alive and all the kids there, people kept quiet about it."

"I noticed the kids sitting together. There must have been a dozen."

"They were the kids he tutored. Paul was peculiar. From the way he talked, all he did was drink, take drugs, and play

tag with his Eddie. But he was spending a lot of his time tutoring kids who had trouble learning or were in trouble or just kids he cared for."

Just then I heard a call-out from behind me:

"Where's the old broad?"

It was Jokkho's name for my daughter. I turned, looked around, and there was Jokkho sitting on a carton in the one empty booth in the lot. There were no tables, nothing to sell. Just Jokkho.

He grunted, and I went over to sit on the ground next to him.

Jokkho explained that he was leaving the flea. After decades, the protector of the flea, who had stood at its gate, was walking away.

He would spend time, he told me, at his shop in New Jersey.

This was the first I'd heard of Jokkho's shop in New Jersey. And why, if he had a shop in New Jersey, had he come every weekend to the flea? Curious about the shop in New Jersey, I made a date to meet him there.

As Jokkho left the open lot that afternoon, never to return, the flea lost the deity who had stood guard at its threshold since it had opened. Jokkho was the last hope against the enemy that would soon erase what remained of the flea.

CODA

As the flea was closing, I took a train and a bus to a neighborhood in Newark that had been Italian and then Puerto Rican and then black. The street was quiet, with a Mexican restaurant on one corner, a car repair shop on another, and between the two a handful of modest two-story homes. A small shop with a tiny window was Jokkho's. Inside the window were Franciscan teacups and a matching ceramic vase. On the door of the shop was a welcome sign and under the welcome sign a phone number to call if the door was locked.

I tried the door but it was closed. I knocked but there was no response. I phoned the number.

Jokkho answered.

He was a few minutes away, he told me, and suggested that if I had not had lunch I might try the restaurant at the end of the block. There was a cheeriness in his voice that I had not heard before.

I went to the restaurant for lunch. Two brothers took orders and set tables; their father cooked. Their mother had died before the family left Mexico, they said. On

the walls were black-and-white photographs of a couple's honeymoon.

Having finished my meal, I returned to Jokkho's. As I arrived, I found an elderly couple staring at the teacups in the window. Their car was parked on the street next to the shop. Inside the car were objects they had purchased from other antiques shops that weekend—a wicker chair, a porcelain figurine of a woman dancing, a picnic basket with leather straps. One of the straps was missing but they told me they thought it could be replaced. The husband had a workbench in the basement of their house and was resourceful. Some of what he made he would donate to charities.

The two of them, having worked hard for decades, were now retired. On the weekends they went to thrift stores and antiques shops. They were not unlike my wife's parents. On their trip this weekend, they noticed the window with the cups.

Half an hour had now passed, and Jokkho was still missing. The couple left.

I phoned Jokkho. He picked up. Seconds later the door opened.

He'd been inside the entire time.

Jokkho was wearing the tennis cap and sunglasses with which I was familiar; but his beard and mustache were ultramarine. This was a new color for him.

Jokkho turned and led me down a dark hallway. I followed him until the light disappeared. It was so dark that from then on, I guided myself by following the sound of Jokkho's voice and by placing my hands on the walls, which were uneven and in places jagged.

A green light appeared at the end of the hallway.

As I proceeded toward it, something struck my face. A long sheet of fabric. I pushed it aside. The green light changed to violet. Hanging in front of me were a succession of decaying wedding gowns and petticoats, filtering the light at the end of the hallway.

Passing through the gowns, I reached the light. A single bulb hung over an enormous room. It was several stories tall and hundreds of feet wide, but it could not be penetrated. For it was filled from floor to ceiling, wall to wall, with broken toilets, doll heads, boxes of rope and nails, incomplete sets of Balzac, empty biscuit tins, rusting cans of insecticide, patent leather cowboy boots, a bronze Krishna playing the flute, a Geiger counter, empty boxes of shotgun shells, portable radios, moth-eaten carpets, motorcycle wheels, bags of foreign coins, model cars and trains, a torn map of Norway, game boards without the pieces, game pieces without the boards, large candied hearts, wood-handled corkscrews from the nineteenth century, portfolios from art students, copies of *Knave* and *Fiesta*, a five-foot-long marlin with "Simone 1936" written in orange across the gills, a light brown vinyl manicure set, an *Inglese/Italiano Dizionario*, a black deco sculpture of a male dancer, still-in-the-package men's underwear, out-of-the-package women's underwear, felt covers for dining room tables, edible chocolate eyes, an eighteenth century iron bed painted a pearl-white, salad plates from an Italian restaurant in Hoboken, a pitted metal sign from a Sinclair gas station, a life-sized translucent model of a human used in a high school anatomy class, clear plastic

bags filled with red and black licorice, a king-sized mattress freckled with cigarette holes, broken sheets of green granite, plastic champagne glasses, pieces of a ceramic horse that had exploded in the kiln, the kiln in which it had exploded . . .

The hallway through which I had just traveled was no hallway at all but a tunnel dug through the body of this material.

Many years before, my first visit to the flea had begun with the small but dense mound of objects on Jokkho's table. Of that mound only the surface was visible, and anyone who attempted to explore the interior was frightened away by Jokkho. What was the reason for this? Why had Jokkho come to the flea if little of what he had was knowable and what was knowable was not for sale?

That small mound, I now understood, was a regent of the colossus of discarded and ephemeral objects through which Jokkho had just taken me. This amalgam—Jokkho's boli— was constructed from the materials and sympathies of the vendors in the flea, including those who had passed away, and it was the sacred inside of the colossus into which Jokkho had invited me.

It was then that I realized that I, like Jokkho, had immersed myself in worthless objects—but that they were only worthless when compared to other items of the same kind (other paintings, vases, books, and dresses). They were valuable, indeed singular, in terms of what they revealed about the people with whom they had lived and how they transformed those people and, in turn, were themselves transformed.

Through the accumulation of the discarded and ignored, these people of the flea—Jokkho, Frank, Sophia, Paul, the

Dane, the Prophet, Alan, Bobby, the Diops, themselves too often discarded and ignored—shared in that elevation.

Jokkho had led me into the garage; and now, decades later, I knew that for as long as the flea continued, however reduced, I would never leave it. The sale of the painting that I'd found there was not my way out of the flea, as I'd once thought. It was my chance to remain.

· · · ·

BACK HOME in my apartment, I found my daughter sitting in an armchair finishing her lunch. She had been brought to the garage as an infant, had grown up there, and now it was near its end. She was sixteen.

I left her and walked into the bedroom. From the top shelf, I pulled a plastic bag. It was carefully closed with masking tape. Returning to the living room, I handed it to my daughter.

She opened it, removing an object wrapped in white tissue.

Inside the paper was a blouse, perfectly folded. The one Paul had refused to sell to the picker on the day my daughter had hidden in the racks of Paul's booth.

My daughter looked at me.

"It's from an old friend of yours. His name was Paul, and he worked in a garage."

Acknowledgments

Thanks to Matt Weiland and Nicole Aragi,
for their brilliance and devotion.